Artculture

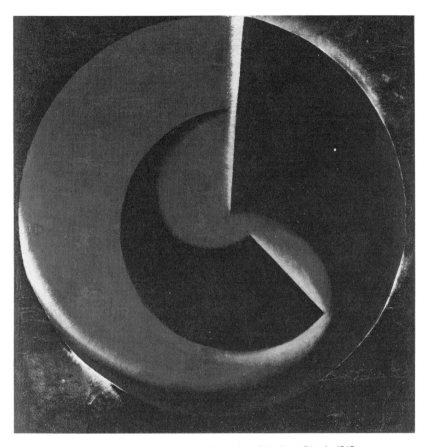

Alexander Rodchenko, *Non-Objective Painting: Black on Black,* 1918.
Oil on canvas, 32¼ ″ x 31¼ ″. Collection The Museum of Modern Art, New York. Gift of the artist, through Jay Leyda.

ARTCULTURE
Essays on the Post-Modern

DOUGLAS DAVIS

Introduction by Irving Sandler

ICON EDITIONS
HARPER & ROW, PUBLISHERS
NEW YORK HAGERSTOWN SAN FRANCISCO LONDON

FIRST EDITION

Designed by Gloria Adelson

Library of Congress Cataloging in Publication Data

Davis, Douglas M
 Artculture.

 (Icon editions)
 Includes index.
 CONTENTS: Artpolitics.—The size of non-size.—
What is content?—Photography as culture. [etc.]
 1. Arts, Modern—20th century. 2. Avant-
garde (Aesthetics) I. Title.
NX458.D38 700′.9′04 76–27504
ISBN 0–06–431000–0

77 78 79 80 10 9 8 7 6 5 4 3 2 1

Contents

Acknowledgments

WHEN I BEGAN WRITING these essays, I had no idea that they would link together as a continuous thought (or chain of thoughts). At first, I was simply looking for occasions that would prompt me to write about topics not normally touched in art writing. Most often these turned out to be invitations to lecture, though occasionally there were invitations from periodicals as well. After three or four were gathered together, several friends and editors suggested that I was in the middle of a book, which quite surprised me. That I kept on—in the face of magazine and exhibition deadlines—is a tribute to their encouragment, though none of them is in the least responsible for the flaws of fact or theory that lurk herein. I ought to add—before I thank these deserving friends— that I have preserved the flavor of the occasions behind these essays as much as possible, save here and there an obvious reference to the lecture audience or an impossibly outdated fact. This means that the reader will have to adjust himself to different tones of address, from the formal and public (for a lecture) to the private (for a periodical). But I cared more about preserving the freshness of the occasions than a calm, even address. The friends who must be thanked for a variety of reasons include John Brademas, John

Cushman, Ronald Feldman, and Allison Simmons. Jane Bell was elegant, brilliant, and untiring, as always. My editor, Cass Canfield, Jr., guided and prodded this manuscript with the warmest civility. Finally, I thank again those institutions that made *Artculture* possible in the most practical sense—by assigning me definite forums to speak or write from, and insisting that I do so on time. These number New York University, the San Francisco Museum of Modern Art, Bennington College, the St. Louis Museum of Art, the American Association of Museums, the Long Beach (California) Museum of Art, the Hirschhorn Museum (Washington, D.C.), the Whitney Museum of American Art, *Artforum* magazine, the *New York Arts Journal,* and the *College Art Journal.*

<div align="right">

Douglas Davis

</div>

January 1977
New York City

Introduction

THESE ESSAYS were written by Douglas Davis over several years and cover a wide variety of provocative topics. Yet they add up to a coherent whole, clearly but not deliberately shaped by a single vision. They achieve their unity by confronting in diverse contexts related issues of consequence in art today: the nature of content; of scale; of art and politics or, as he calls it, "artpolitics," without so much as a hyphen to separate the two terms. His purpose, or better, mission, is twofold: to expand our awareness of what art can be *and* to enlarge the intellectual or critical matrix within which problematic art is dealt with.

Above all, these essays are a passionate, closely reasoned and clearly articulated call for fresh ways of discussing content in art, that is, content grounded in our present condition. This leads Davis to repudiate any idea that focuses on medium alone and neglects or ignores broader meaning, particularly formalism—Clement Greenberg's notion that each art strives to purify itself of everything not of its own physical properties— and the pop sensibility—Marshall McLuhan's claim that the medium is the message. (In an illuminating passage, Davis treats the indifference toward content as a link between

Greenberg's and McLuhan's conceptions.)

Repeatedly, Davis challenges the "selective seeing" of the formalist and pop views, detailing their insufficiency, their refusal to ask, as he believes both art and criticism must: What are the moral and political consequences of aesthetic action? Does art count as art only when it is about art? What other messages—subjective, symbolic, visionary—does a medium communicate besides itself? At the same time, he refuses to accept the sacrifice of form for content, and this provides the tension, the dialectical drama of his analysis.

As an example of the scope of Davis' thinking, consider his amplification of the concept of "scale" (which is commonly equated with size)—beyond the physical into the social.

This dictionary idea of scale has to be exploded entirely, in order to understand the full range of its modern redefinition in art. Depending upon the medium and the strategy employed, a work of art can now act in any one of several kinds of scale—time (as in film, videotape, and story); rapidity and ease of dissemination (as in printmaking, pamphleteering, photographic reproduction, and circulation through the mails); the size and nature of the chosen audience; the ecological cycle; and the extent to which the work penetrates the social-political context in which it is created. In other words, the scale of a work of art (particularly in the 1970s) can be measured by its effect upon the whole culture.

Davis insists that the "urge to speak out on political and social matters" is a legitimate concern of art, artists, and critics. This connection between the private and public aspects of art, between art and social issues, and between the structures of the art world and those of the social system has recently been expropriated by an outworn and vulgar Marxist rhetoric. Davis' mind is too subtle to suffer "self-righteous" condemnations of Western society and the art created in it, that is, the notion that Abstract Expressionism was the painting of the Cold War, and that subsequent forms are equally suspect if for no other reason than they were made in America. He is well aware that at present it is only

in liberal societies that criticism and action against the state are possible—and he is sympathetic to much of that agitation. "There are no Mardens in the U.S.S.R.," he writes, although artists there have not stopped trying. Indeed, as an artist, he has collaborated with two young Russian conceptualists, Vitaly Komar and Alexander Melamid, whose work is advanced and post-modernist— beyond the esthetic of the Moscow dissidents as well as the official painters.

Given Davis' occupation with artpolitics, he is disposed to an art of mind that reaches out into the world. As he views it, the medium that can best effect social change now while being used to make art is videotape—and as an artist, he works in this form (among others, such as performance, drawing and printmaking, for he prefers to cross media). His conception of television is diametrically opposed to McLuhan's, for Davis argues—convincingly —that the message is the medium. He is nonetheless sympathetic to all media, past and present, and he is in no sense a "futurist," as he is often mistaken to be. In this book he deals at length with issues raised by photography, film, painting, and sculpture. In his comments on the traditional visual arts, he favors what the late Gene Swensen called the Other Tradition, the line that leads from Dadaism and Surrealism to "dirty" assemblage, "obsessed with the social and physical specifics of the world around it."

Davis has fought vigorously to preserve and extend public-access cable television because it is necessary for the health of democracy, and because it possesses enormous potential for political change. But not only his social consciousness but his art consciousness enters in, because it is through public-access television that video can reach what he considers its *authentic* audience— the audience watching at home in an intimate, private space. This awareness of the double nature of art, its potential idealism and self-sufficiency, informs all of Davis' essays. He sums it up in a little story. "Form and Content approached each other on the infinite line, traveling fast. 'Where are you going?' asked Content of Form.

'To the end of the line,' answered Form, 'away from you.' 'So am I,' said Content. Then they collided."

Finally, Davis' ability to keep the whole culture always in mind is responsible for his most serious, brilliant and daring insights. Whether one agrees with them or not, they are all pertinent and provocative, particularly today, after two decades of reductive formalist and pop hegemony in American art.

IRVING SANDLER

Artpolitics: Thoughts Against the Prevailing Fantasies

He shook his head. "It is not easy for the Russians, politics. You Americans are born politicians; you have had politics all your lives. But for us—well, it has only been a year, you know?"

—John Reed, *Ten Days That Shook the World,* 1917

ALTHOUGH ROBERT MORRIS has lately been telling us that we are living through a period in which the private sensibility has taken precedence over the public (in a recent *Artforum* he wrote that artists are now "deeply skeptical of experiences beyond the body . . . of participating in any public art enterprise"), I myself can't recall a time when the politics of art were so openly and heatedly discussed. There is an irony in this situation which I will leave for you to ponder. My present purpose leads me elsewhere.

Two incidents have triggered these discussions, which are being carried on wherever I go, and both of them concern *Artforum* magazine. I apologize for this emphasis, but let us not forget that *Artforum* has played a role in contemporary art since 1965 roughly akin to that of the *Wall Street Journal* in finance and

First presented in lecture form at New York University, April 1975, as part of the art-critics-in-residence series, and revised later for publication in the *New York Arts Journal.*

1

Pravda in the Kremlin. First there was the Lynda Benglis incident, in the fall of 1974, to which I will refer later. The second is the heated reaction to the now infamous "political" issue of *Artforum* one year later (October 1975). Please believe that it is only the reaction that concerns me now—not the specific value or nonvalue of that issue (in fact, I thought the earlier issue, in February 1975, devoted to the selling of Pasadena and the buying of the Hirschhorn, much stronger). Certainly most of you recall the quality of outrage that greeted *Artforum*'s apparent swing in editorial policy. It was best summed up in articles written shortly thereafter by Hilton Kramer in the *Times* and David Bourdon in the *Village Voice*.

Let me remind you of the basic point made by each writer. Kramer argued that Kozloff and Coplans were hypocrites for turning upon the art system that nurtured and fed them. Bourdon ended his long and discursive attack by charging the most heinous of sins: that *Artforum* no longer cares about art, that its persistent emphasis on sordid political issues blinds us to the "art on the walls." These are dated remarks—granted—but they have been said. They are there in front of us, naked and glistening. You will know why I consider this argument so significant when I finish. These incidents—and the discussions they have provoked—are far more significant politically than the antiwar movement within the art world in the middle and late sixties. Why? Because they force us to examine ourselves, and to think about the system within which we think and work rather than a system far from our immediate control, like the Pentagon. Moral righteous indignation comes less quickly to our lips in these cases, for we are all touched by and implicated in them.

The earlier Lynda Benglis incident had three parts: an article by Robert Pincus-Witten on the work of Lynda Benglis; a large full-color photograph of the nude Ms. Benglis (laid out as an advertisement in another section of the magazine) holding a giant dildo between her legs; and a long, somber letter to the editor signed

by five of *Artforum*'s editors themselves, protesting the publication of this "object of extreme vulgarity." Beneath the surface of this scenario runs a habitual course of art-world behavior that I propose to isolate and define. Let us focus on a section of the letter, signed by Lawrence Alloway, Max Kozloff, Rosalind Krauss, Joseph Masheck, and Annette Michelson, that has been scarcely noticed:

The advertisement has pictured the journal's role as devoted to the self-promotion of artists in the most debased sense of the term. We are aware of the economic interdependencies which govern the entire chain of artistic production and distribution. Nonetheless, the credibility of our work demands that we be always on guard against such complicity, implied by the publication of this advertisement. To our great regret, we find ourselves compromised in this manner and that we owe our readers an acknowledgment of that compromise.

This incident is deeply symptomatic of conditions that call for critical analysis. As long as they infect the reality around us, these conditions shall have to be treated in our future work as writers and as editors.

Simply as an experiment—and to get the movement of my thought and this essay off to a quick start—I propose to translate freely this section of the letter into direct language, colored by my own entirely biased interpretation of the inferences that lurk behind its words, as follows:

This advertisement makes it seem as though the space in this art magazine is for sale to artists and their dealers. Certainly we know that everything in the art world is for sale, including ourselves. But our reputations will suffer if we aren't careful, at least in public. The dildo ad forces us to justify our association with this profit-making art system to you, the readers.

This incident proves that the capitalist system of making, publicizing, and selling art ought to be criticized, by somebody. If the system doesn't watch out, or reform itself, we will have to do the criticizing ourselves. And Lord knows we don't look forward to it.

Granted that I am rewriting the Artforum Five, their letter still comes off as morally absurd and politically insensitive, neither of

work. It is not a matter of conscious ideology; it is far deeper than that: it is selective seeing—the context in which things are seen.

Mid-nineteenth-century viewers of these paintings *did* see their political qualities, which I contend are fused into the visual context of the work; they are not "literary." The reactions were immediate and highly emotional, both for and against: a rightist critic called *The Burial* "an engine of revolution"; for the socialist P. Petrosz it was "an eminently just and revolutionary idea." Delacroix's *Liberty,* though it was painted in the warm afterglow of the Paris uprising of 1830, was not shown until the spring of 1831, by which time the Right had restored order. The critics attacked it, of course; not long afterward, the minister of the interior bought *Liberty* and put it in safe storage, away from the public. After another populist uprising (in 1848), *Liberty* was shown and admired at last—but briefly: once more the Right returned to power; once more *Liberty* was returned to the storage rooms. The French had yet a third barricade to face, this time in 1871, when the city was briefly taken and ruled by the Commune. Courbet joined the Communards (as Baudelaire had done in 1848 with a different faction), went to jail with the losers, and died in exile six years later.

Events like these make the contention that high art is above politics, devoid of politics, or unrelated to politics appear ridiculous—or at most a contention which holds only in some minds in some periods for certain highly specific reasons—the chronological connection between Greenberg's theories and McCarthyism is no accident; the first defended against the second. As viewers of the paintings, we need not know the specific facts behind them nor the life of the painter. To understand them, we need only accept the fact that art is inherently political, as Daniel Buren says, and indeed, as is every other facet of life. I cannot overemphasize that from this premise flows every other consequence, including the way we read paintings and interpret political activism in art.[4]

We all now accept that activism without question, but I take it further. Activism is instinctively suspect, and the nature of that suspicion colors our judgment of works and entire careers. We cannot yet accept the artist's participation in politics—his talking, writing, voting, organizing (to say nothing of using politics as esthetic material)—without a price. But surely this is contrary to the nature of man. To think about politics is an act of the mind; the mind is central to the artmaking process: therefore to cede politics a part in this process reinforces the rigor that is inherent in it. Political thinking gives the mind full rein, and thereby completes the goal announced—but not practiced—by Duchamp.

Courbet's political involvement has often been dismissed, in the last fifty years, as the consequence of simplicity and innocence. Clark's books go a long way toward righting that balance, itself simplistic, but they are as yet unread. The Hollywood view of the artist as childlike naïf—a view cherished by too many curators, critics, and collectors—is a particularly pernicious form of paternalism, which robs the artist, in this case Courbet, of his humanity, of his natural right to be a citizen. In his 1855 manifesto he wrote: "To know in order to be able to create, that was my idea. To be in a position to translate the customs, the ideas, the appearance of my epoch, according to my own estimation: to be not only a painter, but a man as well; in short, to create living art—this is my goal." These words have been printed in a thousand textbooks, yet are rarely understood. Any artist now who acts on that advice is automatically considered less than serious (about his product and his image perfecting).

Thomas Messer's statement when the Hans Haacke exhibition was canceled by the Guggenheim Museum in 1971 takes up an old and honorable contention: art, he said in defense of his case, has no business dealing with specific political facts, only with metaphors.[5] Haacke did not get into the Guggenheim; Brice Marden recently did. I happen to respect them both, and I juxta-

pose them only to point out how relative is the canon of taste. At this time and in this system, political involvement is permissible only in moments of great and widely accepted national outrage (such as the Cambodian invasion in 1970 and the Watergate crisis). Otherwise it is considered diversionary and diluting: Marden, who has never succumbed to politics, is more serious— by these standards—than Haacke, or Joseph Beuys. On its face, this result is absurd, but it is the predominant standard. The artist now is not allowed to be a citizen, save at cost to his reputation. He is expected to leave the business of the world to dealers, collectors, curators, and, naturally, politicians. What amazes me about this situation is not that it exists as a concept, but that it is believed in—by most artists.

In a more controlled, less open society than ours, the artist has no choice but to act as citizen—either to save himself from highly overt persecution or to widen his area of choice. There are no Mardens in the U.S.S.R.; there are fewer and fewer in Latin America. Intelligent, tough-minded organization has been a matter of necessity for the dissidents in Moscow and Leningrad; all the options and their consequences had to be thought out, in common, among themselves and among the handful of collectors who supported them—the Russian middle-class intelligentsia and the Western diplomatic communities. The luxury of private communion and production, and the equally luxurious removal thereafter from the means and implications of marketing, was not possible. After the celebrated bulldozing incident of September 1974—and the less celebrated, but more significant outdoor exhibition one month later, granted for three hours by the government—the dissidents were harassed, importuned, and pressured in a thousand ways. They held their ground, even refusing on one occasion the offer of an official "indoor" exhibition in Moscow—an unprecedented concession —on the ground that the time and conditions were not right. Finally, in February 1975, the dissidents agreed to an officially

sponsored exhibition. Although the *denouement* is not yet played out, I am unaware of any point during this bitter duel between power and art at which the artists proved themselves less tough, practical, or politically decisive than the authorities. The October 1974 exhibition was on the surface the Soviet Woodstock: there are the same faces, hair styles, and sense of communion. But it came about not as the result of leisure-time radicals' reaching for a quick and exorbitant profit; rather, it came about because a group of artists organized and acted as an effective bargaining unit in a trade-off with superior physical power.

I cite this not only as yet another example of the symbiotic link between art and power, but also as proof that neither is helpless before the other. I repeat that protestations to the contrary are as much based in political self-interest as in historical fact. The American artist finds this difficult to believe because he has been taught insistently to the contrary and because his own basic right to work is rarely threatened—overtly—in the liberal, permissive society. Thus he is rarely moved to organize, work collectively, or apply his considerable intelligence to large political questions. In one way or another, his basic need—to work, to exhibit, and in some measure, to live—is taken care of. The situation of the artist in American society is thus the perfect illustration of Marcuse's basic argument in *One-Dimensional Man:* that resistance to the libidinous technocratic state is impossible. But the refusal to act and think politically is not given in the stars: it is primarily a matter of premise. If the theory of art were taught differently in our system, the reality would change. If the students at Bennington were aware of Walter Benjamin and Joseph Beuys—as well as Greenberg, Noland, and Caro—the short-lived and incontestably pathetic wave of political activism that rolled through the art world between 1968 and 1972 would have accomplished more than it did.

This wave was initiated, as Therese Schwartz points out in her

valuable series of articles on "The Politicalization of the Avant-Garde," by an overpowering public disaster (the Vietnam war), which was the only excuse lately allowed the artist for political action.[6] It culminated, as Ms. Schwartz says, in a large public meeting at the School for Visual Arts in 1969 to discuss the reform of the Museum of Modern Art. This meeting is significant not only because no coherent collective organization followed it—which would have been the only practical means of discussion with MOMA, not to say negotiation. It is notable because speaker after speaker saw the problem only in one light: how to open up the museum's exhibition schedule to more artists (and presumably to himself). In other words, the American artist here—as everywhere—sees his problem simply as one of getting his image-product out on display.[7]

Not that I despair. It is primarily a matter of changing the theory, as I said before. Furthermore, there are significant events taking place within the American cultural infrastructure that will speed (if not compel) this change. The most important of these is the rapid growth of public funding (voted by Congress and by state legislatures) as a major means of supporting artists. As the means of making art thus become politicized, so does the artist. Recently a friend urged me to help him get together a group of artists working in video to draw up guidelines for a "model contract" to replace the contracts we had been asked to sign by public-supported TV stations and experimental centers. When it was ready, we held a meeting and invited representatives of the several superfunding agencies. As might be expected, some of them spoke for the model contract, some against. Later that night, my friend confessed stark terror over the implications inherent in the divisive road we had taken. "From now on," he said, eyes white with fright, "we will have to work and act collectively."

What is wrong with acting collectively? Only the belief that by doing so, the artist relinquishes the psychic individuality that is his

prime value, as product, in the art market. At this point it may seem that I am flirting unsystematically with Marxist ideas, without accepting their full consequences. But I have always flirted that way, and so have you. The Marxist theory of inevitable class struggle is as much a part of our instinctive intellectual baggage as formalism, minimalism, or "Art After Philosophy." It is furthermore extremely useful as a means of analyzing art problems because it is so alien to us. Without it, we would have considerable difficulty seeing ourselves—and our art system—from any distance whatsoever. In the Soviet Union, for example, I am considered a formalist; I cannot imagine what they think of Walter Darby Bannard. There is a good deal of Marxist thought and Capitalist-Structuralist rhetoric in Alloway's valuable essay "Network: The Art World Described as a System." Here it is:

It is . . . a "negotiated environment." That is, long contracts with suppliers and customers, adherence to industry-wide pricing, conventions, and support of stable "good business" practice. . . . What is the output of the art world viewed as a system? It is not art because that exists prior to distribution of art, both literally and in mediated form as text and reproduction. The individual reasons for distribution vary: with dealers it can be assumed to be the profit motive and with teachers it can be assumed to be the motive to educate, with the profit motive at one remove. Art galleries, museums, universities, publishers are all parts of the network-like knowledge industry, producing signifiers whose signifieds are works of art, artists, styles, periods.[8]

This is a very modified Marxism, as you can see. Alloway allows the work of art to exist before the system (motivated by profit) and further allows motives to participants within the system beyond profit; he is also at pains to insist on the nonhierarchical complexity of the art system, in which all participants play increasingly complicated multiplaned roles (Rubin as collector-curator-critic; Thomas Hess as editor-collector-critic-curator; Alloway himself as curator-critic-teacher-editor; to which might be added a whole phalanx of artist-writers, such as Bochner, Bannard, Plagens,

O'Doherty, and your speaker). I quarrel with none of this, on its own ground.

What I quarrel with is the notion of the network as self-contained entity. None of the characteristics which Alloway attributes to the art world—multiple roles, profit-making, high-powered distribution of the product, information as support system—is unique to it. They are at one with the world outside. Indeed, we are the world outside; we are not inside anything, save our own delusion. The art world is a microcosm of the world's macrocosm. It can never be changed (save incidentally) until the macrocosm changes. Thus the idea of the "guerrilla art worker" is a contradiction of itself. He can only be a guerrilla across the board, if he means to be truly effective.

None of what Alloway said—or what I am now saying—would impress any disciplined sociologist or political scientist. It is a highly naïve and rudimentary analysis. It is valuable only because it signifies the desire and need to understand the art world in some tougher and clearer manner than it has been seen before. I take this as a sign of growing sanity, not neuroticism. It is the archetypal behavior pattern of any organism trying to grasp the nature of its environment in order to survive by change, both innovative and adaptive.

For all its ungainliness, the letter from the Artforum Five indicates the same desire, years after it was fashionable to attack art-system corruption. From that entire period of dramatic confrontations, withdrawals of art, and manifestoes, only a few figures continue to command our consistent respect—Hendricks and Toche are of course two examples,[9] as is the late Gene Swenson, whose macabre shouting and pacing echo now in the brain like uncomfortable dreams. For all its imperfections, the belated struggle by certain artists to obtain a royalty interest in the resale of their work is also evidence of this desire, not that I think it will seriously alter the way art business (or indeed any business) is done. The special *Artforum* issue in

February 1975 devoted to the capture of the Pasadena Museum and the creation of the Hirshhorn complex in Washington is yet another symptom. I see all these acts as evidence of a new interest in artpolitics—that is, uncovering how the art world is run, and why.

Recently I attended my first meeting of the International Association of Art Critics, an organization loosely affiliated with UNESCO. A squadron of new members had been voted in by the old guard. The first subject proposed for public debate at the next meeting—and the only subject in which virtually everyone seemed interested—was this: the relationship between the critic and the commercial art gallery. One of the members protested that this relationship is a myth. It was a feeble protest, and drowned out by those who replied: Let it be proved a myth, then.

The least that can be concluded from this long summary of recent activity is that there is a deep-seated sense of unease. No one is ready to defend, on philosophical grounds, the mechanics of artbusiness. The felt consensus seems to be that it needs drastic change.

How can it be changed? Can we speak—from inside a small, fatally flawed system hung on a larger, equally flawed system— of creating art that is in any real sense revolutionary? The answer of the avant-garde since Duchamp has been clear: to attack the status of the art object. I will not bore you by repeating the many rhetorical assaults that have been made on the art-object-as-commodity, nearly all of them tinged with self-righteous Marxism; most of you are familiar with them, from Duchamp through Douglas Huebler and Carl Andre.[10] The core of the argument is this: that by refusing to produce objects signed with a name or stamped with a personality, the artist is defying the materialist needs of the art market, and by extension, capitalism itself. We are coaxed to believe that artistic work that does not result in an object—a performance, say,

or a Happening—or that ends in an object so ugly, mass-produced, or insubstantial as to mock its very existence (Andre's found metal strips; Kosuth's definitions) is in itself revolutionary, as well as a valid increment in the artistic dialogue. Both the argument and the result are in error. The anti-object position ignores conveniently the transparent truth that performances, Happenings, the person of the artist himself, and Andre's metal strips are all susceptible to trade and sale—in brief, to objecthood.

Nothing in the private capitalist system can avoid commodity status, just as nothing in the state capitalist system (such as the U.S.S.R.'s) can avoid ownership by the state itself; in the U.S.S.R., everyone and everything is owned property. I furthermore question whether the real issue before us—as artists—is to destroy either objecthood or the evidence of the single person, rather than the ethic of the system which exploits both.

Michael Daley has recently questioned these premises also, in a stimulating series of essays in *Art and Artists*.[11] Daley has managed a neat trick—to prod the esthetic left from its left flank. His argument, based on a highly selective reading of Marx, is this: The unique individual personality was highly valued by Marx; the self-destruction of art (precisely the sort of self-justifying, spiritually enriching labor that he prized) is justified on the grounds that capitalism renders art a commodity that is nihilistic and counter-revolutionary. Finally, the very existence of art is a destructive force in later stages of capitalism, particularly the kind of art that we might consider idealistic or humanistic: for Daley, Vermeer's *Guitar Player* is more revolutionary than Duchamp's bicycle wheel.

Daley does not quote Marx on the nature and purpose of art, but I shall, briefly, quote the famous passage from the *Economic and Philosophic Manuscripts* of 1844 in which Marx compares the refinement of the subjective human sensibility to the perfection of man's physical senses—and that in turn to the

perfection and extension of his social senses, concluding: "The forming of the five senses is a labour of the entire history of the world down to the present." We also know that though Marx and Engels insisted that philosophical change of necessity precedes political change, both of them saw implicit in certain kinds of art a distinctly counterrevolutionary narcotic value: "It must be a blessed feeling for a legitimist, watching the plays of Racine," wrote Engels, "to forget the Revolution, Napoleon, and the great week." It is important to keep these points in mind when considering Daley's definition of "revolutionary" art, and Marcuse's after him. Marx and Engels stake out a position that is well to the left of Daley and Marcuse—and in fact contradicts them, on the issue of the *function* of revolutionary art (which, according to Marx and Engels, is to *extend* rather than *preserve* perception).

It should also be remembered that Daley's attitude toward the avant-garde now and toward the Russian Constructivist vanguard of the 1920s (against which he rails in his essays) is essentially the same as Lenin's and Trotsky's. The credit for suppressing the Constructivist movement in painting, sculpture, film, theater, and architecture had been given to Stalin, but he merely finished what his colleagues discretely began. Trotsky wrote the first critical essay on Tatlin's *Tower* and welcomed an exhibition of realist art depicting the virtues of the great Red Army—which proved to be highly popular, needless to say. Lenin tried unsuccessfully to discourage the printing of Mayakovsky's poems by the state publishing house and was incensed at the tree-painting episode (one night a few Constructivists painted the trees outside the Kremlin yellow and blue).[12]

The result of these attitudes is the sad, exhausted, and pitiful state of Soviet art today, against which the dissidents are finally rebelling, with some success. A similar result would attend the prosecution of Daley's theories in the West which are not dissimilar to those voiced today by various politicians and funding

bureaucrats, who are asking that merit be subjugated to popular appeal, social relevance, place of residency, and the head count on the tax rolls. This is roughly as absurd as dispensing grants to scientists on similar grounds—a step neither the American nor the Russian government would ever take. Why? Because art at its most advanced state has never been a popular activity; not will it ever be. Like science, the making of art is a highly specialized, demanding, and exhausting activity. It will never be fully understood by those who need or use it only as a decoration of life. Functioning on that level, art does indeed act as a narcotic, playing a role akin to that performed by science in the Middle Ages: providing proof for *a priori* assumptions.

If we are to agree with Daley, then—and with Davis—that the avant-garde is blind to its own hypocrisy, naïve about the political context in which it works, and thoroughly sentimental about its effect on the outside world, we are still not permitted the conclusion that it is counterrevolutionary. Despite its present exhaustion, the long war against the object has undoubtedly focused attention on the mechanics of art production. The truth is simply that the avant-garde is devoid of fresh ideas, still yoked, in its core premise, to a position announced by Duchamp fifty years ago; second, as I have already indicated, it refuses to think through the social and political implications of its actions with anything like the intelligence it devotes to purely esthetic-gestural problems. In this sense, as I argued in "What Is Content?" the avant-garde is no better than Greenberg himself, against whom it rails in name only.[13] When Kosuth tells us in "Art After Philosophy" that art can only be about art, he is saying substantially the same thing that Greenberg said in a lecture in 1971 at Bennington College: "The esthetic or artistic is an ultimate, intrinsic value, an end-value, one that leads to nothing beyond itself. . . . Knowledge and wisdom can funnel into, can serve, the esthetic, but the es-

thetic—like the ethical or moral in the end—can't serve anything but itself."[14]

There is nothing wrong with this historic, well-known position except that it is politically blind. I have no objection to Greenberg's case (art only as art) as a working method; indeed, the rigorous concentration on the thing itself to be done (or seen) that it teaches is invigorating and useful. But there is no end in itself in anything we do; we work, exhibit, and experience always in a larger context of events and of previously received values. The hermeticism preached by the private Western esthetic is an illusion; every time we think we are alone with art we are rudely awakened as by the knocking at the gate in *Macbeth*—by a Schafrazi or a Russian bulldozer. More to the point, the purist position is inhuman, denying the natural desire of man to act and shape his environment. No theory of art that denies or discourages so fundamental a drive can long endure—and I have already shown (in "Content") that the repressed urge to speak out on political and social matters is already evident in Flavin, Rauschenberg, Morris, Levine, the early issues of *The Fox*, and others.

What, then—if the avant-garde is exhausted and the formalists in error—can be done? I'm not going to prescribe answers, and thus join the camp of ideologies and prescribers. But I will talk around the answer in two ways—one esthetic, the other practical —and then conclude by dealing with Marcuse, perhaps the most eloquent defender of art-as-art-as-revolution. I begin with the premise that art is a narcotic only if misused; that its central purpose is to awaken, not to pacify, a premise shared by Max Raphael, among others, who points, as proof, to "the attempts made to blunt [art] for the very reason that it is feared as a weapon (not as a narcotic)."[15] If Raphael is right, we are then led to the conclusion that a revolutionary work of art must begin that way: in fine, it must be revolutionary in medium. This does not totally discount painting or any of the traditional modes of presentation: both

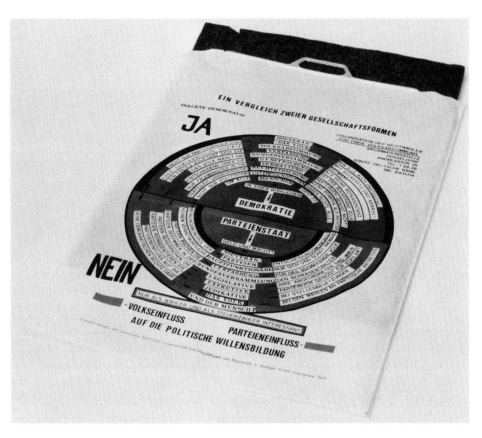

Joseph Beuys. *Organization for a Direct Democracy,* 1969.
Multiple (shopping bag). Courtesy Ronald Feldman Fine Arts, New York.

Delacroix and Courbet presented two revolutionary concepts as paintings. But their timing, focus, and content were extraordinarily sharp. Both their works appeared in the midst of a series of physical uprisings, which were familiar to the viewers of the day. In scope and roughness of form, these paintings were additionally calculated to provoke rather than entertain. This is very far from the arts of painting as they are now practiced, very far from one more colorfield by Olitski or one more storefront by Estes.

This leads me to talk about Beuys's much-maligned political party and about the video "movement" (misunderstood, if not maligned). After Beuys came to the United States for the first time in January of 1974 to continue his dialogue about changing the structure of Western society, the reactions (in conversation, not in print) were diametrically opposite to those I heard in Europe. There, curators and critics are at pains to reassure you that Beuys's party is only art, not serious politics. Here, people tell me—professing disappointment (with a sigh of relief)—that Beuys's work is only politics, not serious art. It is a measure of the rigidities on both sides, but ours is definitely worse.

What Beuys has done, it seems to me (even more successfully than Haacke, whose photo-documentation of ghetto real-estate systems I also admire), is to fuse high art and high politics. The strength of his work lies precisely in its chameleon structure, which holds from beginning to end: at once in the nature of the presentation (through posters, drawings, and verbal statements, and dialogue, and dress) and its substance (ask for a referendum on decentralizing state power; base the objective of a new society in creativity, not greed; begin in education, by deemphasizing grades). The form of presentation—which is the "oscillating sculpture" of the dialogue—is of course revolutionary. For Beuys to have presented his work as a painting, a sculpture, or even yet one more *Aktion* Happening would have immediately mired it in art-historical mud. The entire

work is rigorously thought out and furthermore organizes a complexity of materials and events that puts the organization of a Noland or a Nauman to shame.

That the rigor of its social and political strategy virtually transcends any artwork made here need hardly be said. In this connection, I am amazed by those who say (here or in Europe) that Beuys is simply kidding, or that he is—like all artists—politically naïve. Let us remember what he has done: changed the curriculum of the Düsseldorf Academy (a major state-supported art school); caused a nationwide debate about the nature of art (and all) education; won a case in federal court voiding his dismissal, reinstituting his professorship and all his back pay; and even now he is maneuvering to gain state support for a "free academy" of art, open to international constituency. These are hardly acts of a naïve man, incapable of acting successfully in the real world.

Which brings me to video. What I will say about it I have said many times before, but apparently it bears repeating, for diametrically opposed viewpoints are continually ascribed to me, and to others (i.e., that we are obsessed with the medium as an end in itself). Video is by nature a revolutionary form of address, once its nature of transmission and its effect on perception are rigorously thought out. Here again is evidence of the way in which art and politics can be made one force. The same application of intelligence to this new medium that has been and is applied to the flat surface and the brush yields similarly startling results: there is no such thing as a "mass audience" for television, in physical fact: there are only one, two, or three persons watching, on the other side of the set. In broadcast, an artist reaches a large audience, but in a private, casual space. The possibility of communication at a direct and highly intense level is thus present. It is at this moment that the artist can transcend commodity, the narcotic trappings of the commercial art system. The videotape exists in this sense as a naked communicative symbol.

That this simple but quite incredible fact has been ignored in most writing about video (and most work in video) is another symbol of the malaise I am isolating in this essay: the refusal to think beyond the surface of the work, and of the art system. Although copious opportunities exist to broadcast, most artists (and needless to say, most dealers) prefer to act only in terms of closed-circuit or installation space. Worse, the purveyors and spokesmen for art video often claim that by keeping the prices of videotapes low, they are working in harmony with the democratizing quality of the medium. Nothing could be sillier. The proper revolutionary function of a videotape is in broadcast, where it reaches an audience in one instant many times larger than the audience for a \$250 videotape. The sale of the videotape as an object—with which I do not disagree—is a support system for this work, and its price should be pegged toward that end; not toward a false concern for democracy.

That note of practicality may be upsetting since in the art system, practicality is rarely allowed to enter public or critical discussion, though it is of course at the core of artbusiness. But it is in fact an essential ingredient of social or political change. If a truly revolutionary work of art must be revolutionary in medium and address, it must also be supported by a revolutionary life. We have all had enough of flamboyant anti-art rhetoric yoked to private wheeling, dealing, museum-mongering, and selling. The most extravagant charges of corruption are leveled at the art system, so extravagant that anyone who attempts to work for change within that system is—by terms of this rhetoric—immediately suspect. Meanwhile the rhetoricians proceed to aggrandize themselves and sell their work, without flinching. This is precisely what Daley and many others have complained about in the avant-garde; there is a corollary in the New Left/media university-mongering of the late 1960s. It is no wonder that the art world seems to outside observers like Sophy Burnham a treasure chest of cynicism.

I do not oppose impractical or ineffectual tactics on moral grounds; I oppose them (and the letter from the Artforum Five) because they are counterrevolutionary and intellectually lazy. I ask for a closer correlation between personal ethics and public rhetoric, based on the simple fact that we can change the world only in the present tense. We can work only with what is at hand, with what is possible *now*. If I want to address my art to the world, I must address it through the system, as must everyone else. If this sounds suspiciously like liberalism and compromise, so be it: liberalism and compromise is the only way any true revolutionary has ever worked, save through the sword, which none of us has in hand. I cite to you the examples of Lenin and Trotsky—not because I admire the state they eventually created but because they are often cited as heroes of moral absolutism. The list of their compromises would take me pages, from Lenin's adoption of capitalist principles and his promise to give the ownership of land to the peasants (later revoked), to Trotsky's signing of the disastrous peace of Brest-Litovsk, which gave away one third of Russia to the imperialist German state in 1920. Compromise and politics are inseparable from living; death or armed uprising are the only alternatives.

What this means to us now is disappointingly clear; if the 1969 speak-out on the Museum of Modern Art had ended in the formation of a coalition to negotiate from a broad consensus for changes in the museum, that would have been a revolutionary act. The grand gestures of removing works from the museum or sitting on the steps of the Met are not. I am hardly against all gestures: at the proper moment they can be the occasion for effective provocation (as was the case with Delacroix's *Liberty* and Courbet's *Burial*). The occasion of the cancellation of the Hans Haacke exhibition by the Guggenheim in 1971 seemed to me to be precisely such an occasion: the issue was specific, clear-cut, with broad implications for the future. But the art world did not react in anything like the numbers

and energy that were warranted. It prefers to act or to rally on farcical grounds, with a sure taste for perfecting its own image of impotence and silliness: I cite here both the defacing of *Guernica* (with photographer posed for documentation) and the letter from the Artforum Five. The latter is a perfect case, as I said at the beginning, of failing to apply rigorous practical intelligence to the larger implications of a quintessentially political issue (the selling of space in an art magazine to parties interested in the editorial content of that magazine).

It is difficult to believe that the Benglis incident was the first of its kind to occur at *Artforum*—or any other art magazine—or that the five editors awoke one morning with a start to discover the realities of art business. As a united front, they could have demanded reforms in this practice long ago, and still can. The public protestation of indignation, without private follow-up, is sham radicalism.[16] So is the failure to connect the practice of artbusiness to the practice of all business—that is, to the larger implications of the Benglis incident and all comparable incidents, which occur daily.

What are these larger implications? I am going to list now a few developments in the world outside that merit the conscious attention of artists—not with the view in mind of producing work that concerns them in any overt way, and certainly not even to encourage flamboyant, meaningless action. Nor are they issues that will shock you with their newness: we think and talk about them constantly and naturally, but they are never allowed even to become "information," in Greenberg's terminology. Here they are: the hidden economic interests of curators and critics in the art they discuss; the mysterious accounting procedures employed by most galleries; the incrementing power of the new art bureaucracies in funding agencies; the dwindling of public commitment to education and research (in science as well as space); the militarist (as opposed to economic and cultural) bias in our foreign policy; cul-

tural and ethnic persecution here and abroad (very definitely including the Communist countries, who are rarely criticized by the Art Left). I certainly do not ask that such issues become the overt content of contemporary art. That would be a step backward, to the pieties of social realism. I simply ask that they be allowed to filter into the collective consciousness, as legitimate concerns of art—as legitimate as billboards or linguistics. The result—as I said in "What Is Content?"—is unpredictable, as form.

The genuine revolutionary—that is, the man or woman genuinely interested in changing what we are and have been—will not have to be so addressed. He will not have to be told—even if he is an artist—that he can speak, write, or act on these issues without losing his esthetic purity, or rigor of professional purpose. But I begin to suspect that few of these genuine revolutionaries exist. The present system nourishes and deludes us too well (into believing that art is only about art). It even nourishes our cheap desire to be thought of as revolutionary by allowing us freedom of rhetoric, without insisting that we match our lives to the rhetoric. To direct ourselves beyond that is not a matter of dedicating ourselves to left, to right, and certainly not to Utopia (as it is conventionally understood—more of that at another time). The conviction required is this, no more: that the past is not prologue, nor should it be; it is something to improve on, as quickly as humanly possible.

In his celebrated lecture at the Guggenheim Museum in 1971, Marcuse—ostensibly the prophet of revolution—told us something else. He claimed that the authentic oeuvres in contemporary art maintain a safe and privileged distance from reality, in pursuit of an alienated truth and beauty ("the construction of an entirely different and opposed reality"). The trouble with Marcuse is that he thus further encourages art and artists to disengage themselves from specific issues susceptible to change—as does Doty's interpretation of certain highly charged

photographs—and therefore from politics, which I take to be a natural component of a fully human life. The kind of art preferred by Marcuse—a natural consequence of his thesis—is soaked in narcotic qualities: Beethoven, Mahler, and Monet (an echo of Daley's affection for Vermeer-as-revolution). In a metaphorical sense, he keeps art and politics as two words, in the manner of the recent attacks on *Artforum*. I have argued that the two words are one, whether we like it or not, inseparable and inalienable, to be ignored or carelessly defined not merely at our personal peril, but at the peril of the work of art itself, which is sited inevitably in the world.

NOTES

1. The last time effective political activity was openly joined by the New York art community was during the late 1930s, when an artists' union was formed, pamphlets protesting museum policies were issued, and court action prosecuted. Furthermore, the abstract artists were as active in the campaigns as the realists. See Susan Larsen, "The American Abstract Artists: A Documentary History 1936–1941," and Gerald Monroe, "Artists as Militant Trade Union Workers During the Great Depression," *Archives of American Art Journal*, Vol. XIV, No. 1 (1974), pp. 2–10.
2. *The Art Crowd* (New York, 1973).
3. *Image of the People* and *The Absolute Bourgeois* (New York, 1973).
4. An excellent example of the importance of premise—and how it effects both theory and interpretation—is Alexander Rodchenko's lecture on "The Line," delivered at the Inzux Institute in Moscow in 1921. Rodchenko came to flat, minimal forms long before Greenberg or any of the Minimalist theorists of the fifties and sixties. In this essay he describes the history of art in purely reductivist terms, moving toward the final great goal of form as line, and line alone. Yet it is everywhere tinged by Rodchenko's own political optimism, based on the recent triumph of the Revolution. In other words, a mind alert to politics is also fully capable of rigorous attention to

form (in advance of the American formalists themselves). See "The
Line," introduction and notes by Andrei Boris Nakov, *Arts* maga-
zine, May–June 1973; also Nakov's "Alexander Rodchenko: Beyond
the Problematic of Pictorialism," *Arts,* April 1973.

5. Messer's statement may be found in the Guest Editorial, *Arts,* Sum-
mer 1971, pp. 4–5. Carl Baldwin points out in a recent review of
Photography in America at the Whitney Museum that the specific
content of "humanitarian" photographs made by Lewis Hine, Paul
Strand, Walker Evans, and W. Eugene Smith is consistently general-
ized in Robert Doty's catalogue and wall-label descriptions. Thus is
the political content of Smith's Minimata photographs—based on the
poisoning of air, water, and food—neatly emasculated.

6. *Art in America,* November–December 1971; March–April 1972;
March–April 1973; January–February 1974.

7. In the first issue of *The Fox,* a periodical clearly devoted to the poli-
tics and sociology of art (though it was edited in part by a few early
Conceptualist theorists), there is this account of an "open" meeting
on the nature and policies of *Artforum* magazine, at Artists Space in
October 1975 (proving that nothing has changed since 1969): "The
artists complied [with the magazine] . . . marvelously, asking, for the
most part such penetrating questions as 'how are artists selected for
review?' and 'why don't West Coast artists get equal space?'—to
which the editors replied with enthusiastic superiority." Karl Beve-
ridge, "A Forum on *Artforum,*" *The Fox,* Vol. 1, No. 1 (1975), pp.
138–140.

8. *Artforum,* September 1972.

9. The prevalent art-system criticism of Toche's struggle against Douglas
Dillon's FBI-assisted arrest is a perfect example of the political bias that
lurks behind esthetic judgments. Time and again it is said that Toche
is a bore and his guerrilla letters bad art. What about Dillon? Is his
Aktion-to-arrest interesting? Is it quality art?

10. A great many of them can be found in one book, *On Art: Artists'
Writings on a Changed Notion of Art after 1965,* ed. Gerd de Vries
(Cologne, 1974). I particularly recommend the statements by Andre,
Huebler, Le Witt, Robert Morris, and Lawrence Weiner.

11. "Crisis or Revolution," March 1974; "Left Turn," July 1974; "Left
Turn," August 1974.

12. The public record of Mayakovsky's attempts to defend the so-
called unintelligibility of his poetry before party bureaucrats and
"popular" poets between 1925 and 1930 (when he committed sui-

cide) are revelatory in this regard and may prophesy similar confrontations to occur here later, as city, state, and federal bureaucrats gain increasing power over artistic activity (through grants) in the United States. Several of them are available in *Mayakovsky: Poems,* ed. and trans. Herbert Marshall (New York, 1965). Two of these exchanges are quoted verbatim in this book; cf. "The Idea of a Twenty-First-Century Museum."

13. "What Is Content?: Notes Toward a Definition," *Artforum,* October 1973.

14. To be fair to Kosuth, it must be admitted that his recent public statements—as well as his article "The Artist as Anthropologist," published during his abortive involvement with *The Fox,* a journal that was resolutely Marxist, in 1975–76—indicate a new concern with issues beyond the picture plane. *The Fox,* Vol. 1, No. 1 (New York, 1975).

15. As quoted in *Marxism and Art,* ed. Maynard Solomon (New York, 1973), p. 33.

16. By the way, in the same sense that the Benglis ad smoked out underlying half-hidden political truths—and did so through a revolutionary (for art) medium, advertising (and lately, T-shirts)—it may well be an example of inadvertently effective political art.

The Size of Non-Size

IN 1960 PIERO MANZONI executed a line in a Danish newsprint factory that stretched 7,200 meters. This act is relatively well known, but another and similar work is much closer to my present subject: the *infinite line*. About this he said: "An infinite line can only be drawn leaving aside all problems of composition and size: in total space there is no size.[1] Here Manzoni comes close to the concept of scale implicit in virtually all the work that has been called "post-Minimal" or more loosely, "post-modernist," minus a social-political dimension. On the physical level, we are no longer concerned with *prescriptive* size—that a work should be large or small according to its formal needs. Artists are ready to use any size, in the service of needs that are nonphysical. We live at a moment when artworks veer from one extremity of scale to another, without concern for style or genre.

The irony is that this fact—and the topic of "scale" itself—is rarely discussed. The issue has not yet surfaced as an open subject for dialogue for two reasons: "scale" is no longer fashionable, because it has gotten a bad name from the propagandists for "impos-

First published in *Artforum*, December 1976.

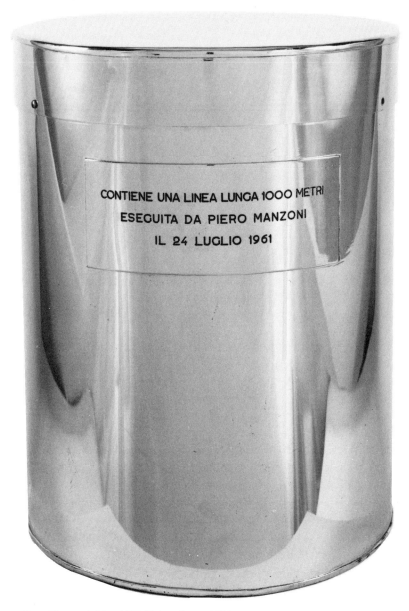

CONTIENE UNA LINEA LUNGA 1000 METRI

ESEGUITA DA PIERO MANZONI

IL 24 LUGLIO 1961

Piero Manzoni. *Line 1000 Meters Long,* 1961.
Chrome plated metal cylinder containing paper, 20¼″ high. Courtesy Museum of Modern Art, New York. Gift of Fratelli Fabbri Editori and Purchase.

sible art," as well as the indoor Nevelsons, Calders, and Caros blown up to expensive size for use in city plazas. The term "art for public scale" has become in this sense a hollow mockery. More importantly, certain attitudes toward scale (or nonscale) are so pervasive and deeply rooted that no one feels it necessary to discuss them: they are as tightly locked inside current art as the concept of the flat picture plane was in the sixties. There are occasional references to scale by such artists as Terry Atkinson, Hans Haacke, Robert Barry, Mel Ramsden, Ian Burn, and Eleanor Antin (the last in correspondence with the author), but no straight-ahead writing. It hardly needs to be said that contemporary critics have rarely touched the subject either. Thus I am on fairly untrod but fertile ground. Surely the issue of scale—once examined—will reveal hidden assumptions fully as relevant as the more modish subjects now demanding our attention (video, story art, or the October Revolution).

The first step, obviously, is to discard with Manzoni the primitive notion that "scale" is a matter of physical size. This encrusted idea is based not only in the materialist ethic of formalism but in Renaissance esthetics. The dictionary still defines scale as "the proportion which the representation of an object bears to itself" —a central problem, in brief, of realist painting. This dictionary idea of scale has to be exploded entirely, in order to understand the full range of its modern redefinition in art. Depending upon the medium and the strategy employed, a work of art can now act in any one of several kinds of scale—time (as in film, videotape, and story); rapidity and ease of dissemination (as in printmaking, pamphleteering, photographic reproduction, and circulation through the mails); the size and nature of the chosen audience; the ecological cycle; and the extent to which the work penetrates the social-political context in which it is created. In other words, the scale of a work of art (particularly in the seventies) can be measured by its effect upon the whole culture, in terms of its pre-determined arc of action—where it attempts to go, the issues it

tries to confront, and its chosen audience.

The matter of the audience is central to my view of scale, and obviously conflicts with solipsist attitudes toward artmaking. While the work of art is gestated and completed in private, the act of exhibition projects it outward, and renders the work a public issue. This step—the consequences of which are normally ignored in art writing, where the meaning of the work is nearly always assumed to be at one with the artist's intention—is a fateful and complex one. Art writing assumes that artists' and viewers' interests are entirely convergent. Among other consequences, however, the act of exhibition invites the world beyond the studio to interpret the work, thus sharing the metaphorical destiny of art (its meaning) with others. This particularly applies—for good and ill—in the twentieth century, which has proliferated means of communication, making it virtually impossible for the work to adhere to its original intention, scale, color, or texture for very long. This is so even for artists who obdurately insist on the one-way nature of the work: Reinhardts and Pollocks are known to the vast majority of their public not in their intended physical terms, rife with nuances of texture and undercoating, but in the smooth, flat, and reduced form of photographic reproduction. In recent years, artists have even begun to use certain of these disseminating devices (the photograph, the book, the mailer, video) as primary agents of their work, rather than secondary or reproductive. Clearly mode of address and actual encounter condition perception, and this entirely social exchange demands analysis.

Where is the audience? Who makes it up? How large is it? These are questions crucial to the full understanding of recent art, in all its apparently disparate forms. They can be applied to four-hundred-ton monoliths standing alone in the desert, anticipating an audience via photography and art-magazine reproduction, as well as words planted as flares on the landscape of Long Island, which anticipate the same, and to post-Happening interpersonal activities set in motion by the artist far from center stage—but later

reported extensively in photo-text documentation. Story art assumes a reading audience, moving from point to point of the narrative in a public gallery, rather than a private space (such as the audience for the postcard, book, or exhibition notice). The assumption is the same in the intricate, content-rich maps and studies of Newton and Helen Harrison. But they deserve a meditative attention perfectly in harmony with their physical scale, and perfectly at odds with the public gallery, a context that discourages slow, sustained reading.

Video assumes several disparate audiences, which it often confuses—the audience for sculpture (for video-based installations in gallery spaces); the audience for film (sitting in rows of seats to watch videotapes played on gallery/museum monitors); and the authentic video audience (watching at home in an intimate, private space).

Here we must distinguish between the nature of the art audience and the nature of the "audience" as it is commonly defined by filmmakers, by commercial television, and by McLuhan-influenced media theorists. Generally I'm speaking of a shifting entity called an "art" audience—i.e., one conditioned to accept an esthetic experience often of a difficult sort. But within this group there are obviously many differing constituencies and expectancies. Though any of the works I describe here might in time "reach" millions of viewers, that is certainly not their proper intention. Art is by definition more difficult than entertainment and therefore less likely to attract/hold large numbers of people. This is not a distinction that I mean to give up, nor does recent art, regardless of its medium (video can be as "difficult" as painting, even when broadcast). Current art may come to us via exhibition, catalogue, telecast, and reach us alone, in groups, in well-lit galleries or dark, crowded rooms, in the morning, or in the evening. Each of these contacts affords us its distinct rhetoric, whether direct or mediated. In no sense is the deliverance of the art statement an impersonal one, neutral, without specific context, devoid

of a value system that needs to be assessed (popular media theory notwithstanding).

The way in which we perceive audience (or ignore it) is motivated in part by political values and moods. I have already argued (in "What Is Content?") that political ideas can frequently infiltrate form. The same is true—even more sharply—of scale; though not in the naïve manner often argued (i.e., Art Must Expand In Size to Save the World). The events of the past decade have definitively laid to rest the rosy mood of the early sixties—when nothing serious seemed to matter—and made it impossible to continue the making and judging of art in isolation from other, broader concerns. The anxiety inherent in recent artmaking and writing (I refer here to the *Artforum-October* debate, to the extreme Marxist analyses that characterize *The Fox,* to the doctrinal split within the Art-Language group as a whole and to the activities of the Artists Meeting for Cultural Change) is an example of this. Why are these things occurring? For those who yearn for Business As Usual, for a return to parties, Pop, and glamor, these debates seem irrelevant to the art process. Seen from another side, the argument is perfectly natural. The seventies are a decade in which appalling truths have finally become clear to large masses of people, from the poisonous quality of the air we breathe to the stupendous revelations of corruption that accompanied Nixon's resignation. The perception of the audience is directly related to this sense of political and physical breakdown. The result, in fact, is not an art of propaganda but an art that is two-way (among other things) in dialogue with its considerable (and influential) audience, often on matters that seem heavy, pretentious, and extra-esthetic to the Pop/Ironic sensibility. An art engaged in this particular expansion of scale (into audience) is thus a cultural phenomenon that often alludes to or enacts a justified anxiety.

In stressing the importance of audience and of content, I am once again repeating the obvious point that scale in art is much more than a matter of physical size. In fact, the locations beyond

size are precisely the points that interest me most—and lead us toward a dematerialized conception of scale. Size is a decision of mind, not of hand. The choices that confront artists in making a work of art perform this way or that are often unmindful of physical necessities. Criticism is deficient when it confines itself to formal issues, ignoring the decisions that determine content through this crucial issue of scale.

Although I am attempting to discuss scale in nonphysical ways, the matter of quantitative size can hardly be ignored. Here, too, we find that decisions in art reflect a complex of deep cultural attitudes, as well as information. We cannot perceive—or choose —what we do not know, or care about. Aristotle's attitude toward scale in the *Poetics* is bounded by what he knows: no object that is a thousand miles long can be beautiful, he says, for "the eye cannot take it all in at once." He could not comprehend or accommodate a scale that is now available to us (thanks to the satellite). Aristotle could not have seen that far even by ascending the highest mountain. The Renaissance concept of scale was molded by the needs of a realist esthetic. Not until late in the nineteenth century —when vast vistas of the earth's surface were beginning to be domesticated by the train and by aerial-balloon photography—did the propriety of a post-Aristotelian physical scale begin to appear in art history. Here it is, in John Ruskin's words: "No beauty of design in architecture, or of forms in mountains, will entirely take the place of what may be called "the brute largeness.' That is to say, the actual superiority in feet and inches over the size of Humanity, our constant standard, the general truth being that . . . the greatest effect on sublimity will be produced by the largest truth which is clearly manifested to us."[2]

But I am not arguing in behalf of brute largeness, or against it. I am arguing that either extreme of size (down to the smallest) is workable, but only when it is inextricably wound into the form, content, and intention of the work. So are extremes beyond size. On the level of definition alone, Ruskin obviously takes into ac-

count neither the temporal implications of a work of art (or architecture) nor the social and political context in which the work appears and on which it acts. An analogy in recent experience is Christo's *Running Fence*, the latest in a series of projects launched in the sixties that are conventionally understood to be ambitious and effective explorations in esthetic scale. In a formalist sense, they are. Christo's projects cover many miles of outdoor space, the bare condition (it would seem) for post-studio art. They furthermore engage the sixties sense of process perfectly, requiring the help of hundreds of workers over long periods of time (often several years) before they are finished. Yet these workers and the landscape of the work (most recently the *Fence*) are employed simply as a means toward an end that has nothing to do with them, in any deep and permanent sense: to produce a Christo.

The *Running Fence* engendered considerable public and political opposition, none of which deterred Christo, who often declared that he welcomed the complaints and controversy, which simply enriched his work. After a series of bitter court battles, Christo won all the county and state approvals needed to erect the fence, which ran from the edge of the Pacific Ocean across Marin and Sonoma counties in California. At the conclusion of the last legal case, Christo announced to the bitterly divided courtroom audience that every man and woman there had become an ingredient in his art, whether they were for or against the fence. In other words, Christo understood the political controversy over the work as an aspect of form, not as content. The specific value of the issues raised by the opposition—which included that of psychic as well as ecologic intrusion—were subsumed in the art-life continuum, first defined by Cage, later by Kaprow and others.

But art is not life, as we certainly know: it is an activity encircled by life, upon which it depends. Christo is thus wrong to oppose his critics on the ground that they (the life issues) are simply art materials. General Motors might well dump refuse into the water we drink, on an equivalent ground, that it is a tautological act

without wider ramifications. The *Running Fence* is an example of Ruskinian scale, insensitive to the political implications of its high-keyed presence in a rural landscape, and unresponsive to the needs and objections of the local audience it pretended in part to serve (the real audience is, of course, the international art community, which attends the *Fence* from afar, through the media of drawing, photography, and film).

In saying this I'm not questioning Christo's motives. From the beginning he has acted in all his large-scaled projects in perfect fidelity to his premise (that art is life and therefore permitted equal ambitions). His work has followed through a certain notion of expanded scale to a logical end. More than many other artists he has carried the implications of certain sixties ambitions to their purest corporate resolution. (Recently Christo was invited to be guest speaker at the Young Presidents Organization next February; like them, he took over a corporation before he was forty and attracted a multinational group of investors.) The results, however, must lead us to stop here, to reassess our premises, and to find a rationale in scale that leads toward more positive meaning, rather than ambition, chaos, or form as form.

A cultural definition of scale, as I said, would rid itself of the notion of proportion and encompass time and politics, as well as size. Why time? Because it's hard to believe in or support a theory of art based on fixed, unchanging values or needs. This is the basic argument against the monolithic and static form, in architecture as well as art. Colin Rowe has argued cogently against the fatal paradox in modernist building: in the service of a supposedly public goal, modernism has erected an unending parade of bland, faceless, and functional structures, towering over cities throughout the world—a feat of construction unmatched in human history. What began as a method allied with socialist politics became —with the collapse of European socialism in the thirties—an arm of capitalist monument-making, or form divorced from its usual content. The alternative now is either to build or design in league

with time (permitting rearrangements and change at a later date, in the manner of John Johansen's Mummer's Theater in Oklahoma City) or to confine the art of advanced architecture to private, domestic dimensions.

The work of Peter Eisenman and Michael Graves, centered on weekend homes and preexisting houses, serves this altered sense of scale. Eisenman's House II in suburban Connecticut argues for an architecture of symbol and meaning far from the acute concentrations of urban movement. Graves's addition to the Alexander house in Princeton is equally polemic, correlating form and color with the ritualistic functions of light, room, doors, and columns. This is admittedly mandarin architecture that avoids public imposition, unlike the Christo *Fence* or the megalomaniac stadia recently reared by the Gaullist architect Roger Taillibert for the Olympic Games in Montreal (at a cost of more than one billion dollars and eleven lives lost in the rush construction). Temporality and modesty (of physical bulk): these qualities are inseparable from the sense of scale in post-modernist art.

Since Picasso and Gertrude Stein, it is banal to say that the contemporary experience of the world is spatially complex. More important, it is temporally complex. Our sense of time is open and abstract—to the point where we are willing to allow for reversals and curvatures as well as sense the movements of time across sequences and spatial segments beyond our immediate experience. Performance, film, and video (most of all) serve this cycling, pressing sense of time moving on. Aristotle argued not only against objects more than a thousand miles in size but against plots that stretched out beyond the point where all of it could be easily held in memory. Robert Wilson's plays stretch from twelve hours in length to 168 hours; rather than compress or actually represent time, he expands a minute of "real" time into an hour of theater time. Roger Welch's film *Welch* is a pastiche of home movies made at differing times in his family's life, merging—when seen in whole —into one tenseless moment. Alan Sonfist's abandoned *Animal*

Hole is a form in time, created by the life needs of its occupant, tunneling through the earth. The live telecast can transmit a focused sense of this passage of the immediate moment, shared with the viewer. My year-long collaboration with Vitaly Komar and Alexander Melamid in Moscow (in a four-part series of performances) is predicated on simultaneity. It began as an exchange of photographs by political necessity as well as esthetic choice. We perform (and photograph) at precisely the same moment, separated by thousands of miles of space/time, yet sense the simultaneity of the act. Later, the spliced photograph collapses these miles into one plane and one image.

It is no accident that the photograph served this work well, allowing us to collaborate together beyond the reach (if not the surveillance) of competing political systems. Cheap, flat, and accessible, the photograph is the signifier of recent art, as canvas-stretcher and steel frame served its predecessors. The photograph furthermore calls no attention to itself (as medium), unlike film and video, which also figure largely in the subject under discussion. The fact that Eleanor Antin's *100 Boots* originally circulated entirely as a postcard image is now a matter of indifference to its audience, which can only remember the boots as image. James Collins's voyeured girls are undergoing the same transformation: they appear in so many guises and scales (postcards, magazine reproduction, framed gallery objects) that they lose any identity with physical scale, and medium. I myself think that video art will never begin that process until it becomes cheap and readily available, via cable television broadcast. Only then—divorced from the prestige of its medium and its museum, gallery, or prime-time broadcast context—can the content function as such, freed from its obtrusive mode of address.

Contemporary criticism is often blinded by extremes of scale. Rhetorical attitudes are always attached to works that expand or contract beyond the norm. We assume that a small painting is intended for an intimate audience or that a large one is "public"

in nature, that painting itself is private, while a videotape is public. There is no specific basis in fact for these assumptions (is a Joan Jonas videotape less private than a painting by Lowell Nesbitt, a tiny Rosenquist more private than a large Pearlstein?). Nor is there any basis for the persistent notion that an artist who actively engages in politics in his work is "Utopian" or "anti-art." Beuys's decision to undertake dialogue with a constant, changing public is a proper use of scale in the service of content of his political *Aktion* (to ask for a referendum on the structure of government in Germany). The scale of Haacke's works—reaching into interlocking ghetto-midtown entrepreneurial systems and the track record of paintings caught in the snares of the art market—is perfectly consistent with the intent of the work, which is to materialize otherwise invisible machinations. Indeed, the full awareness and esthetic use of art in the exploration of contexts beyond itself provide—to my mind—a core potential of new work. Of course, virtually every attempt to broadcast a videotape engages a corporate or market system at one level of difficulty or another, as does art writing itself (which must of necessity find publication in the pages of magazines subsidized by art dealers). Christopher Cooke's little-known 1971–72 work, *Limited Interval Administration Project,* dealt exclusively with extracontextual systems. Cooke deliberately incorporated his activities as a museum professional in this work, using his own tenure as director of the ICA in Boston as its source. In his successful proposal to the board of trustees, he stated:

Any and all activities of this year may/will be recorded for use as a comprehensive exhibition which will be the result of this year's activity. The work consists of: 1) the process of directorship; 2) notes, tapes, films, documents saved by the artist during the year; 3) activities, events, and things generated by the artist in the process of carrying on this project.

Equally relevant to my present point—though less premeditated—was Walter de Maria's year-long *Proposal for the Olympic*

Michael Heizer. *Double Negative,* 1969-70.
240,000 tons displacement in rhyolite and sandstone, 1500′ x 50′ x 30′. Collection Virginia
Dwan. Courtesy Xavier Fourcade, Inc.

Games (1971). Planned and offered as a site piece on a hill over-looking the 1972 games in Munich, it contemplated drilling a cylindrical hole through the hill itself and deep into the earth. The proposal was debated and discussed heatedly by the Olympic Committee and in the press, and de Maria found himself forced to defend and clarify it in public time and again. The argument concerned itself with the nature of sculpture (de Maria contended that form could be created by physical absence as well as by presence), of conception in art, and of execution. The proposal was thrice debated in this manner—accruing complexity and public involvement at each step—and thrice defeated. Had the form been realized, de Maria's work might paradoxically have run the same moral risk inherent in Christo's fence.

I have been deliberately describing recent works that deal with aspects of scale beyond size. Their actual form is frequently nothing more than a photograph, a book, or a performance. What, then, of extreme physical size? When can it be employed? Terry Atkinson maintains in *Art Language*[3] that Duchamp has left us at a point where any size is within reach: "If a bottle-rack can be asserted as a member of the class 'art-object,' then why not the department store that the bottle-rack was first displayed in, and if the department store why not the town . . . and so on, up to a universal scale." This is the classic (if ironic) statement of scale as gesture. It ignores both the meaning of the gesture and its effect upon the context beyond art. It assumes that there is no difference between a massive Heizer triangle standing alone in the desert on its own land, beyond harm or harming, and a running fence cutting across an exurban landscape walked and cherished by others. The Duchampian position also assumes (wrongly) that art is free to do whatever it wishes because it is impotent and beyond meaning. Udo Kulterman announces in *Art and Life* that the time has come to deal with universal scale and quotes with approval the *Aktion* of Marinus Boezem, "who had the idea of signing the universe with the help of an airplane whose condensation trails

would spell out his name."[4] Again we see the refusal to think through the moral and political consequences of esthetic action: in this case (as in Christo's) the "gesture" endorses the notion that the selfish or solipsist act is justifiable, if it ends in art. The extension of art into massive physical size is a complex, fragile, and portentous step, not to be taken lightly. The reason for this caution is and ought to be the power of art as a philosophical model for the audience it increasingly attracts. The same is true of political discussion, theorizing, and acting.

The problem of scale—and its use—is inescapably and properly a matter of a consciousness that shapes larger values. Its changing definition is a function of changing cultural needs. I have tried to demonstrate that the physical size of a work of art is simply one of several components that describe its scale, and that the work may function successfully on many expansionist levels, whether or not it is large or small. Sheer size alone (as in modernist plaza sculpture) is irresponsible and boring. Far more important are the means by which the work extends itself in time and in politics. I am partial to—and argue for—accessible, low-cost media, such as the photograph, cable television, radio, the postal system, the book. I am also partial to the rare act that opens a medium heretofore closed—network television, the line between East and West, the global communication satellites—but accessible by its very nature. The situation obviously forces the artist to contend with extra-art issues, in order to work effectively. Both creating and observing are conscious and informing acts, and both make the culture we live in. The infinite line exists beyond form but not beyond meaning.

NOTES

1. Cf. Germano Celant, *Piero Manzoni* (Turin: Sonnabend Press, 1972).
2. George Landau, ed., *The Aesthetic and Critical Theories of John Ruskin* (Princeton, 1971), p. 207.
3. "Introduction to Art-Language," Vol. 1, No. 1 (1969).
4. Udo Kulterman, *Art and Life* (New York, 1971), p. 184.

What Is Content?

WHAT IS CONTENT? It has been several decades since the question has even been raised, much less answered. Once content was held to be a natural component in the work of art, as natural as color or facture in painting, form or mass in sculpture. Since publication of Clement Greenberg's *Art and Culture,* however, we have been led to believe that it is a corrupting agent in esthetic structures that are irreducibly visual and experiential, directed at the eye rather than the intellect. We have been trained not to seek a meaning in art beyond its corporeal components. I believe that we are about to leave that indoctrination behind, that it is time to begin thinking about content again. Not in the traditional way, not in the rhetorical terms left over from narrative painting or Social Realism, but in new ways, grounded in our present condition. I furthermore believe that a proper understanding and use of content—of symbols and meanings that point toward the outside world—is the fulfillment of a desire explicit in Duchamp and implicit in much recent work in painting, performance, and linguistic proposition—the restoration of the mind to art. These are notes toward that end, and toward a definition.

First published in *Artforum,* October 1973.

The proper definition of content might further liberate American criticism to deal with the immediate past, with the few modernist artists who depend heavily upon content and have so far escaped serious evaluation or understanding here. Among this small group are Edward Kienholz and Diane Arbus. Kienholz's audience is primarily in Europe (where he is misread, too, for obvious reasons, as a builder of anti-American political tableaux, such as *Five Car Stud,* exhibited at Documenta in 1972). As for Arbus, we are already being told that her photographs of psychically and physically scarred people have nothing to do with the people themselves—with content, that is.

Harald Szeeman's Documenta V, rightly understood, is a step in this direction. It is as natural for a European curator like Szeeman or an artist like Joseph Beuys to work freely with symbols, meanings, and nightmares, unburdened by the memory of *Art and Culture,* as it is unnatural for someone like Robert Morris. At Documenta, Szeeman organized several varieties of realism in a single wing of the Neue Galerie. The American work, grouped largely by Jean-Christophe Ammann, represented the so-called New Realism, which is in fact a retreat forward, toward content, away from the iconic blandness of Pop art. New Realist images are much closer to real images, to genre painting, if you like, than Pop. In certain cases—Malcolm Morley's *Gulfstream* (1971), an overt protest against the Union of South Africa, with a large red "X" painted over the landscape of Johannesburg, and very nearly all of John Clem Clark's neoclassic paintings, toying with previous literary or visual references (*The Judgment of Paris* is an example) —the handling of content as content is frank. In most cases there is a pretense to formal dumbness. We are told (both verbally and visually) that the photographic image is the subject matter, not the automobile, not, as in John de Andrea's case, the couple copulating, nor, in Duane Hanson's case, the pathos of street bums. But the stronger, sharper, and more lifelike these works become, the less possible it is for anyone, least of all the artist, to avoid thinking

about *what* his forms depict. Ammann organized the show by subject matter, of course: paintings of automobiles followed by paintings of storefront windows and commercial signs, each work straining to pretend that it has no subject, by imitating the effect of photographic reproduction. Seen in this way, the photograph is now serving, somewhat ironically, the evasive needs of a whole generation of painters.

A few more examples of the problem/stasis. Vito Acconci's early events and performances were minimal in iconography and plot. Take *Following Piece,* 1969, which scored nothing more than that —following someone, anywhere, until the end of his trip. Scarcely two years later, Acconci began to deal with deeper psychic needs, though still pretending that it is form; he scored a 1972 meeting at Pier 17 in New York in which he would reveal "Something I would normally keep concealed: censurable occurrences and habits, fears, jealousies—something that has not been exposed before that would be disturbing for me to make public." The moment Acconci takes this step—analogous to the sharp-edged realism of de Andrea or Hanson—is the moment he takes on content. For Acconci to deal directly in the implications of his censurable occurrences rather than using them (unsuccessfully) as neutral material, would be—I suspect—a weakening of the esthetic structure, in his mind. This fear/myth is—negatively speaking—the major factor in current art. Depending upon the artist, it can inhibit development by itself.

Gene Swenson once pointed out that Jasper Johns is a latent literary painter, kept from completing the full cycle—and implications—of his work.[1] Dan Flavin is, I think, a similar case. Why those long, provocative titles and dedications?[2] Behind them is a mind and a sensibility frustrated by the dogmas of anti-content. Flavin clearly lusts for ideological conflict, which he is kept from engaging in his art, except peripherally. His series of *Monuments for Tatlin* need the title in order to communicate the message, a

message that operates beyond the medium employed. Finally, in his extraordinarily naïve and powerful poster created in the service of George McGovern's 1972 presidential campaign, in which a photograph of the candidate was captioned "I BELIEVE HIM," the real Dan Flavin emerged. Very much the same can be said of Rauschenberg's *Currents* and Richard Hamilton's *Kent State*, both products of 1970, the year of the Cambodian invasion and the long-delayed reaction of the Western art community against the war. I find the *Currents* themselves, an endless collage of newspaper headlines gathered over a period of several months, much more visually effective than has yet been allowed. But Rauschenberg's statement, attending them, was another naïve cry: "Art can encourage individual conscience. Everyone's independent devotion is the only vehicle that can nourish the seed of sanity. . . ." The artist skilled in sophisticated visual devices turns Childe Harold when it comes to stating or communicating a message—to dealing, in brief, with content. Hamilton's *Kent State,* a large-edition lithograph based on a live television newscast, is less successful in visual terms and equally banal in strategy: we are invited to view a fallen student through the neutralized surface of the cathode ray tube and presumably rise in anger. Yet the iconic act, the freezing of real time image into lithographic form, accomplishes precisely the reverse: what was affecting on TV news is diffused in lithography, as if the poignant figures of frightened Vietnamese schoolchildren in flight from their bombed, burning homes (an image that McGovern described repeatedly in his speeches) had been stained into canvas.

The point is that we have no skills for dealing with content, after decades of avoiding it. The results—when an artist weaned on experiential doctrines turns to content—are always bathetic, particularly so when he is prompted by chance, for this or that political issue. When modernist art attempts to deal with the real world it cannot do so on grounds beneath its visual sophistication. Flavin,

Rauschenberg, and Hamilton evidence a hidden elitism in the works cited above: when I attempt to communicate with you, audience, verbally or factually instead of visually, they seem to be saying, I must lower my standards. My argument is that advanced art should deal with content in an advanced way, as a natural weapon in its armory. Even so iconoclastic an artist as Les Levine —in the statement that accompanied *The Troubles,* an exhibition at Finch College (1972) based on documentary films and tapes made in Northern Ireland—doubts the proper place of content in art:

The question I asked myself was: are the social and political problems of a society a valid medium for art or should the artist be limited to esthetic values for his expression? As I have worked with several art systems, I think it is my duty to impose these sensibilities on interpreting existing social systems which are changing and affecting our lives at a more rapid pace than we can finesse our culture to cope with them.

Notice the word "impose." How tentatively, then, does Levine approach content, certain that its place in art is an imposition. How free of these reservations is Joseph Beuys, who deals with the real world and his own esthetic on the same level, not sacrificing one for the other. His German political party is an *Aktion,* at once an instrument in the real world and an instrument in advanced esthetics. Beuys does not go to the world and ask it to do good, or to believe in McGovern. He asks it to see art and life as linked, to begin where he begins, before ending in conclusions. "Man, you have the strength for self-determination," he said, in a perform-ance at the Tate Gallery in London. The next step toward the fruition of his goal is his referendum "for a new democracy," at once a practical step and a metaphorical one. In his organizational charts proposing a newly structured society, in his pamphlets, in the hundred days of discussion at Documenta, Beuys demon-strates how a modernist mind can work in the real world as care-fully and acutely as in the studio. The closest American equivalent

to Beuys is the Guerilla Art Action Group, manned by Jon Hendricks and Jean Toche, both of whom are committed to dealing with real-time problems, political and legal, as valid esthetic problems. But none has yet thought sufficiently about form. The error of Guerilla Art is directly opposed to the error of elitist art: it sacrifices form for content.

We handle content badly because we are ashamed of and unskilled before it at once. The content in Rauschenberg's *Currents* is its conclusion, which points toward the world. But the conclusion itself—that the world is in bad shape—is banal. The conclusion implied by Beuys's activities is infinitely more complex, and forces the viewer to decide for or against a particular line of action. Now, neither Rauschenberg nor Beuys is playing a proper game, according to the formalist canon, which maintains that quality art achieves that status by ridding itself of impurities. I need hardly demonstrate the profound absurdity of this position, however, which has been under unremitting attack for almost five years. Though the attack has not been wholly successful, its appearance indicates—as I said before—that we are passing through a transition, from a sensational esthetic to an ideational one. One more comment, before I pass on to a more important enemy. The Cambodian invasion in 1970 may have destroyed the realpolitik of formalism in the United States, by making it impossible to live with, morally speaking. It is then that we witnessed the amateurish spectacle of artists who had built their careers on anti-content suddenly engaging in political causes, demonstrating, destroying paintings, and assailing the morality of a capitalist society to which they were organically bound. On the surface, things have changed: Robert Morris, who led the post-Cambodian withdrawals, has returned to the museums. But the moral malaise continues.

The more I think about it, the more I realize how important in this context was Robert Morris's *Hearing* (1972). In a matter of

years, it may be looked back upon as the major transitional work, not because it succeeded but because it failed. I was immediately struck by the incompleteness of the tableau upon seeing (and trying to hear) it, without knowing what had been overlooked. Had I come across *Hearing* in 1965, or even as late as 1967, I could have accepted it. There it stood, a copper chair, a sheet-metal table, and a lead-plated bed, all burnished, primary structures. But Morris could not stop there, working as he was in post-formal American time. First, the structures were mounted rather dramatically, on a raised platform, and thus elevated above the plane of the specific object. Second, the viewer was warned not to touch any part of the tableau, lest he suffer electrical shock. And last, a tape-recorded dialogue between many voices filled the space. The quality of the recording—and the "actors"—was below the level of the visual installation, and I find this particularly important, considering Morris's knowledge of Beuys. The latter works, as I said before, in a European, pre-formal, post-content time. In his *Aktions*—the Documenta hundred days is an example —the meaning and the symbol are in front, filling the viewer's mind and eye. At Documenta, Beuys debated and argued continually, from morning till night, over the meaning of political power. By unlocking the latent creative powers in the public, he claims, new political structures can be created, then realized, through referendum. Beuys believes that the ongoing dialogue about these subjects—back and forth—is an oscillating sculpture. The dialogue in Morris's *Hearing* is as rich as any single part of Beuys's hundred days, yet it could hardly be grasped by the ear at the installation. I heard it clearly much later, by listening to the tape played on a recorder, close up. Morris's dialogue pits an interrogator and a series of witnesses against a lone defendant. They debate a long series of esthetic and metaphysical points. At one point a speaker says: "Talk is cheap"; his adversary replies: "Objects are not." Morris himself obviously concurs; for he chose deliberately not to raise the audio level of his dialogue so that viewers could hear the

content of the debate he had written and recorded. He preferred to let the sound perform abstractly, below the level of audibility.

The risk is that by dealing in meaning, the work of art may immediately absorb itself into the world, losing its privileged (esthetic) shelter. It is no accident that Beuys was dismissed from his professorship at the Düsseldorf Academy in 1972 (while Morris continues to construct sculpture), or that he pronounces the founding of a free international school his most important esthetic goal. The difference is not between virtue and vice, but between two contrasting esthetic systems. Beuys, not afraid of content, is by now skilled in feinting with the world, and uses it like a canvas, expanding the sense of scale—a subject I have discussed at length in the previous essay—beyond the physical to the social. Morris, trained to avoid meaning, confronts the world on rare occasions, is rebuffed (withdrawing sculpture from the Whitney failed to stop the war in Vietnam), and returns to the sanctuary of non-content. But he breaks out again, in *Hearing*, almost. His tableau offered a stage upon which form, metaphor, and meaning could have met, in a richly articulated, multidimensional work. Yet one dimension failed. Much should have been heard from *Hearing;* very little was.

Hearing nonetheless signified something, as does all the work I have been discussing: a deep, long-repressed hunger for what art needs to complete itself. Conceptual art appears to do precisely that, breaking the hymen protected so faithfully by Greenberg, but in fact it does not. As James Collins says, Conceptual art attacks the anti-intellectual bias of the art-world system while it subtly reinforces and strengthens that bias.[3] Time and again, its statements, definitions, and essays are installed and marketed like paintings, not like linguistic provocations (it is no accident that the catalogue no longer serves as the basic medium for conceptual art messages). This is entirely consistent

with the paradox implicit in nearly all Analytic Conceptual theory. It surfaces most sharply in Joseph Kosuth's essay "Art After Philosophy." Here Kosuth announces his determined opposition to formalist esthetics, and to its sensational, anti-thought premises. Yet in the end Kosuth retreats to precisely the reductivist point where Greenberg begins: works of art, he states, "if viewed within their context as art . . . provide no information what-so-ever about any matter of fact." That is, Kosuth locks himself back into the confines of the work of art itself by this tautological proposition: art is about art, in other words, as science—allegedly—is about science. The work of art is not allowed in either Greenberg or Kosuth to comment on the world beyond, even though language is recognized as a proper medium. "Tautology," now, is a simple synonym for "flat."

But this position cannot hold, least of all in terms of linguistics. The use of language leads inevitably toward content because language is an instrument forged by necessity—by man's need to describe and deal with the outside world. No matter how reductively it is used or how repeatedly hung upon the wall, language inexorably engages the mind through meaning, and the structure of grammar itself. The prevalent art-world bias against meaning is only that, a bias. Morphological rules and propositions are hardly the chance occurrences that many artists have taken them to be. The more we learn about languages, the more we discover how universal are their structures. Each has a grammar which includes a lexicon, a phonology, a syntax, and distinctions between elements that deal in time, space, and number. The proposition that a sentence makes is structurally irrevocable. Language is governed by deep laws; it is also open-ended in terms of its flexibility: since it can re-form itself to state new concepts, it defies determinism. No linguistic proposition can be a tautology, since language does probe beyond itself, into the outside world, which

Daniel Buren. Photo/souvenir of ACT III, at the New Theater, 154 East 54th
Street, New York, on January 15, 1973.
Courtesy John Weber Gallery, New York.

it exists to describe. Already we can see in recent Conceptual-
ist propositions an expanding involvement in issues beyond art.
Daniel Buren recently furnished an astonishing statement for
his exhibition at the Jack Wendler Gallery in London (March
1973). Read aloud from a videotape playing on a lone monitor
in an empty gallery, it began with the now familiar questioning
of the art system, and the conditions of gallery viewing. Yet he
could not confine himself finally to the art system without ref-
erence to the larger system:

All exhibitions here have the same frame, and this frame is not neu-
tral. But to pretend to escape from these limits is to reinforce the pre-
sent ideology which expects diversion from the artist. Art is not free,
the artist does not express himself freely (he cannot). Art is not the
prophecy of a free society. Freedom in art is the luxury-privilege of a
repressive society. Art, whatever it may be, is exclusively political.

Of course Buren lacks the rhetorical and conceptual skills to
implement this essentially public theme. Of course he is better
at picking apart the art system than the world system: So am I,
and so are Flavin, Rauschenberg, Levine, and Morris. We are
all caught in the tautology that art counts only as art when it is
about art. The essential step is to break out of this restrictive
trap, which requires a willingness to integrate the complex self
(with its feelings about the outside world) and the work of art.
The use of content does not require a simplification of the self.
The difficulty inherent in art is a condition of its existence. So
is its source in the intellect. Duchamp proposed a return to this
source, which is why he reclaimed painting for the mind. But
there can be no natural place for the mind in art without
meaning. Content is the expression of mind; it is also the link
between the work of art and the outside world.

NOTES

1. Cf. Gene Swenson's catalogue "The Other Tradition," published by the Institute of Contemporary Art (Philadelphia) in 1966.
2. *Greens Crossing Greens (to Piet Mondrian)*, 1966, and *Monuments for V. Tatlin*, 1966–68.
3. Cf. James Collins's review column in *Artforum*, September 1973, p. 87.

Photography As Culture

I begin with a mental game. On the adjoining page you see an image that is highly charged with political, historical, personal meanings. Most of us remember this moment; perhaps we can even recall where we were when we heard the news that Robert Kennedy had been assassinated, and certainly how we felt about it. The image is in no sense a modernist work of art; no attention was paid to it as form, beyond the simple desire on the part of the photographer, Boris Yaro, to center the slain Kennedy in his lens. It certainly fails as pictorial or painterly photography, that anti-modernist idiom, rooted in nineteenth-century attitudes toward composition and finish.

This is raw and candid photography, performing what we are always told is the core task of the medium: to capture the instant moment, however ungainly. That this photograph is not entirely ungainly—that despite its weakness from the point of view of both modernist and traditional esthetics it still manages a certain visual coherence and power—is almost entirely a function of its content. The man in the center is a specific man, known to us all,

Originally presented in lecture form at the St. Louis Art Museum, February 1975.

Boris Yaro. *The Assassination of Robert F. Kennedy,* June 5, 1968.

representing a certain point of view, a certain position in a political context that is still a part of your life and mine. The horror implicit in the photograph is precisely that: horror, grounded in tragedy. Were this an unknown man, the photograph would be simply gruesome, and sordid, closer to the effect that Diane Arbus frequently has on her detractors than to grand horror.

But let me propose the following hypothesis: suppose any one of us were to take a photograph of this photograph; and then another—a photograph of the copied photograph of the original; and yet another, and on and on, as far as time and patience could carry us, perhaps into hundreds of copies. I am not speaking of precise mechanical reproduction now, but of a freehand snapshot, the kind of photograph each of us could make without undue effort or expense. What would happen? Physically, the answer is obvious. At first the image would fall slightly out of focus; then the line itself would begin to break; shoulders, arms, and legs would gradually flow into each other and into the surrounding fields of black and white; Kennedy's face would be unrecognizable after a while; somewhere into the ninetieth or hundredth photograph it would be a blur of white, not even a face; toward the very end the picture would be a sea of blacks and whites, a kind of soft-edged Franz Kline in small; at the last, as I imagine it— though your own fantasy counts as mine in this little game—there would be nothing but spots of grain on a glossy and largely vacant surface.

Which brings me to the nonphysical questions I mean to ask, and have you consider, while I move toward the end of this essay: What is the content of this final product? If you answer that it is still a photograph, imagine yourself in the position of a viewer coming upon it for the first time. What relationship—in those eyes —does the last abstracted image have to its origin? Is the last image an image still resident with the broad implications of the murder of Robert Kennedy?

That in mind, I can turn now to the state of photography, considered as an art, which is my literal subject. Like any art, its condition is at once a matter of theory and criticism as well as practice: thinking and art are one, contrary to current belief. The condition of photography, so considered, is highly interesting. I can't recall a period when photography was so much discussed, debated, and exhibited as in recent years. Even a selected list is impressive: the Diane Arbus retrospective, which drew record crowds to the Museum of Modern Art in New York in the fall of 1972 (and also resulted in the selection of Arbus for the United States representation at the Venice Biennale—the first photographer thus honored), continues to tour the country, causing a stir wherever it goes; Peter Bunnell was appointed in 1973 to head Princeton's first graduate-level Department of Photographic Studies; in the spring of that year, a large exhibition of new Japanese photography opened at the Museum of Modern Art and traveled throughout the United States; in the Bay Area in early 1974, two large and pointed exhibitions brought out large crowds, the spleen of critics, and letters to the editors of all the San Francisco and Oakland papers—I'm speaking of Thomas Garver's largely straight assemblage of younger photographers at the De Young Museum, entitled "New Photography: Bay Area," and Jerry McMillan's uninhibited "Anti-Focus" at the Richmond Art Center, crammed with doctored, collaged, stretched, squeezed, flattened, fabricated, and three-dimensional images, all dedicated to the proposition that the end form of the photograph is decidedly a matter of free choice; A. D. Coleman, the young and outspoken photography critic, engaged in a running ideological battle with Minor White, one of the saints of his medium, late in 1973, first in a column banned by the *Village Voice* (for which he then wrote) and then in a widely read issue of *Camera 35;* Cornell Capa organized, funded, and opened the first museum in New York devoted entirely to the medium, the International Center of Photography, in October 1974; one month later, the Whitney Museum opened the

first major exhibition ever organized there on the subject of photography; *Newsweek* published a special issue on photography, in both its domestic and international editions, leading to a particularly heavy newsstand sale and mail response; Susan Sontag began to write on photography in the *New York Review of Books,* in a series that unfolded with each essay, like a twelve-layered Japanese kimono; *Artforum* magazine, until recently a bastion of painterly mediums and formalist criticism, published four long articles during the same period on photography; *Arts Canada* devoted an entire issue to "The Esthetics of Photography," also in the fall of 1974; and finally, a major retrospective of the work of Edward Weston, a major polemic force in twentieth-century American photography, opened early in 1975 at the Museum of Modern Art, with attendant seminars, lectures by leading critics, and a follow-up national tour, all certain to raise once more the heated issue of "pure" or straight photography versus "impure," manipulated photography—on which Weston's position is clear and forthright.

Why all this activity now, particularly in areas of opinion and belief that have traditionally ignored photography—or at best, considered it a field peripheral to the central Western arts of painting and sculpture? Like everyone else, I can only speculate; worse, my speculations do not flatter my colleagues in these areas. It seems clear to me, for example, that the convergence of a rising fine arts interest in photography and the medium's demise as a central conduit of visual information is not accidental. Another way to put it is this: photography is now safely removed from the business of the world, even in its contemporary guise, and thus a subject safe for scholars, critics, historians, and conservators. With the death of *Life, Look,* and one tabloid newspaper after another, the possibility that photography might rise as a total medium above the sweaty function of informing the world—now the province of television news—increased. I won't belabor this point: I see it raised in essay after essay, by art historians and critics carefully

trained to regard the practice of art, on the one hand, and the practice of informing, trading, and politics, on the other, as disparate activities. They concede with relief that the photograph is at last history and object at once.

Photography is now viable, in brief, as nostalgia. No longer a source of utility and power, it can cultivate, for a certain sector of opinion, the fine and private message. But I have a few more speculations on the rise of interest in my subject. One of them is that the innovative edge in the work produced by younger photographers since the end of World War II has demanded a critical and curatorial response. The best example of this is the Arbus retrospective. Say what you will of her work—I happen to regard it highly—the exhibition provokes an almost visceral response from its audience. I notice that Susan Sontag refers again and again to these photographs, even while denouncing what she believes to be their moral and political neutrality. Once Arbus's work had gone the rounds of the major museums, the schools, and the magazines, it was impossible to regard photography either as inoffensive or as intellectually vapid. There are several other bodies of work that match it, among them, in my mind, the photographs of Robert Frank and Emmett Gowin, but it is the net effect of Arbus's impact on a wider public that counts the most. It has counterpointed the bland and celebrative view of photography—inculcated by Steichen's hugely popular "Family of Man" exhibition, launched at MOMA in 1955, seventeen years before Arbus appeared in the same spot.

On one level, I agree with those who say that the place of photography in the world (and therefore the arts) has changed. But the cause has nothing to do with photography's loss of power. It has to do with a change in our attitude toward the photographic image (which is of course related to a larger change of mind), evident in the work of Arbus, Frank, and others, and in our reaction to them. Let me briefly and baldly summarize this new attitude, from my own point of view: photography can never again

be what it once was, because we no longer believe in the scientific neutrality of the print. The photograph has ceased to be a window on the world, through which we see things as they are. It is rather a highly selective filter, placed there by a specific hand and mind. Henry Peach Robinson complained in another time—the nineteenth century—that the medium resisted personality: "A method that will not admit of the modifications of the artist cannot be an art." But his conclusion came at a time when the fine arts were dominated by physical crafts, by realistic painting, and by sculpture molded in heavy mediums that included bronze and marble. We are conditioned by other possibilities, ranging from Conceptual art to the highly complicated effect of live, immediate television transmission. Now there is no embarrassment about the rapidity with which the camera gives the artist his image, no pretense that the process implies laborious, painterly perfecting and retouching: when asked how long it took him to make a particular photograph, Gary Winogrand is said to have replied: "About a five-hundredth of a second."

These are recent and very important changes. André Breton once called automatic writing "the camera of Surrealism," revealing the old art belief in the objectivity of the lens. Fifty years later, I would put the case in a directly opposite way: Photography is the paintbrush of the avant-garde. Of all the new media made available to the artist in the past 150 years, photography is the most susceptible to personal interpretation, archiving, and objecthood. It is no accident that during the very hyperactive period I described earlier—through which we are still living—the photograph became a first-class collecting object. Dealers, prices, and trading mushroomed; several seminars took place (the most thorough was published in 1973 in *Print Collector's Newsletter,* reprinting the remarks of Peter Bunnell and dealers Lee Witkin, Harold Jones, and Ronald Feldman) on the key commercial issue of the size of the photographic edition.[1] It had been assumed for decades that the intractable reproductive fertility of the photo-

graph would stay collectors. Walter Benjamin's brilliant Marxist essays on photography and on "The Work of Art in the Age of Mechanical Reproduction," written in the 1920s and 1930s, always assumed that the photograph signaled the end of the work of art as unique and monarchical cult object. Decades later, it is clear that he underestimated—as do many Marxists—the consumptive power of capitalism, which is not an ideology (like Marxism) but an instinct. The conclusion of the seminars and the market is this: The collector is content with an unnumbered old—and famous—original print, because few of the classic cash-value names in photography made many prints themselves; and the younger photographers are prepared to limit editions and destroy negatives, for a price. There you have it. The market is safe. The photograph, unlike the film, the videotape, the performance, or any of the new media discussed in my earlier book *Art and the Future,* is an object, numbered by Standard and Poor's.[2]

There is thus no doubt in my mind that photography is an activity of the mind, proper to the fine arts, and available for collection, discussion, and thinking on the same high level accorded painting, poetry, music, and dance, using many of the same methods. Indeed, it may already be—for my purposes, as artist and writer—a little encrusted. I am attracted to it not as a revolutionary medium but as a memory. Like painting, it has filled our minds and our sensibilities with images based in immediate time, a point to which I will return later, and in specific subject matter. Its appeal to me, and its crucial influence on the development of a new critical method in all the arts, is locked into time and content. The medium speaks to us on a very deep and irrational level: to the instincts of man rather than to his learned critical apparatus. Indeed, the power of photography has only incidentally to do with the photograph as form at all.

But enough of my position for the moment. I will return to these thoughts at the end, when we must take up again the question of the last-generation photograph of the slain Kennedy. If I am about

to argue that the true meaning and importance of photography lie beyond form, others do not, and you should know that. Critical attitudes in the area of photography are presently in a state of exciting flux, but certain core positions are still available. There is an analogy to formalist criticism in painting in the purist approach to photography, which Weston best represents (and Hilton Kramer continues admirably to elaborate), in his insistence on careful composition through the viewfinder, a central, sharp focus, and direct printing of the negative on high-gloss paper, without cropping of any kind. This position is so pervasive now, not only in the art magazines but in high-quality journalistic and fashion photographs, that it is almost invisible, and therefore uniquely powerful. It results in the kind of criticism that discusses Arbus's work entirely on the ground of method, and in photographs in which every blade of grass and every store-window reflection is in proper, balanced place, rather like a canvas by Mondrian.

The purist in both practice and criticism also has a fairly elevated view of subject matter. Weston said: "The spectator feels he is seeing not just a symbol for the object but the thing itself revealed for the first time." Later he spoke of this as "super realism," long before the term had been invented to denote a school of contemporary painting, ironically based on the supposed neutrality of the lens-eye vision. Both Strand and Stieglitz often left the impression in discussing their subjects that they reached for "universals," for images (Stieglitz called them "equivalents") that would stand as metaphors for larger truths, subjective and objective. This position is diffused through the culture, as I said before. The humanistic and journalistic attitudes toward photography share it: what counts is (first) the importance of the subject and (second) the composition of the elements within the picture frame. The humanist—I take Walker Evans's sharecropper portraits of the 1930s as a convenient example—wants most of all to be moved, usually by generalized examples of human suffering. The journalist wants an image that will have an instant and literal

meaning for his audience: a photograph of William Buckley stand-
ing on a podium surrounded by flags is inherently preferable to an
unknown trumpeter marching in a patriotic rally, to mention two
photographs I have recently seen.

In each of these approaches the composition of the image—
laying it out stage center—is desperately important, for reasons
that stretch all the way from ingrained art-historical attitudes to
journalistic clarity. The arrival in the last decade of a wave of
determinedly candid "street" photographers, who insisted on the
reverse, on the necessity of showing a world in flux, with cars, legs,
faces caught in shadow or in motion, shoved the old attitudes
completely off balance. There is still no compromise or détente
between the new and the old approaches, even though the
method I am describing properly defined itself as long ago as 1958,
in Robert Frank's first book, *The Americans.*

The new "street" photography has no concerted critical theory
behind it. The work goes on out of instinct, coupled with occa-
sional democratizing platitudes by the photographers themselves.
But it suggests conclusions I will come to later. So does the nascent
outline of a critical attitude that I will call cross-cultural. It can be
faintly seen in three essays written by Max Kozloff for *Artforum*
in 1974[3] and in Susan Sontag's connected series of articles in the
New York Review during 1973–74.[4] Kozloff is approaching the
core of this position more tentatively, so I will do no more than
refer to his consistent emphasis on the link between the photo-
graph and its time of conception, and to the evident delight he
takes in his subject (these essays seem to me to be the best he has
ever written, on stylistic grounds). Sontag's articles argue more
cogently and forcefully against photography's claims, and in so
doing develop—perhaps unconsciously—a positive position. They
deserve a hearing now, before I show you a group of pictures that
direct me toward the end of this essay.

The core of her argument is this: "The most grandiose result of
the photographic enterprise is to give us the sense that we can

hold the whole world in our hands—as an anthology of things."
And again, more brutally: "Photographs really are experience cap-
tured, and the camera is the ideal arm of consciousness in its
acquisitive mood." What I like about Sontag's writing on photogra-
phy is not so much her specific conclusion as her willingness—
indeed, eagerness—to see it as an arm of the entire culture, rather
than an isolated, disparate entity. The consequences of what she
sees are substantial, and not always of a part: photography
removes people from the reality of the world by pretending to
capture it; the camera provides the photographer with a license
to snoop and to dominate—Arbus's work in this view is essentially
upper-class voyeurism; the photograph is an arm of the ruling
classes of American society, or any society (because power controls
the press, which reproduces the photographs); it is an engine of
surveillance in every state, dating from the identification and ar-
rest of the Paris Communards in 1871; the collection of family and
vacation snapshots persuades people that they have preserved
reality, when in fact it has been distorted and sanitized, as photo-
graphs of wartime atrocities themselves deaden and delude:
"There is always a presumption that something exists . . . which
is 'like' what is in the picture."[5]

Now, there is a lot to be said for the other side. As I pointed out
in an essay (written for the *Newsweek* special issue), the Vietnam
war was the most photographed war in American history and also
the least popular.[6] Nor is there any evidence that the prephoto-
graphic culture was more compassionate and democratic than our
own. But I am most concerned now with the essential effect of this
position rather than its merit, which is not only to see photography
as an arm of the culture, laden with all its feelings, attitudes, and
demotic energies, but totally to reject the notion of camera-as-
window—as truth-sayer, in other words. The several photographs
collected on the following pages anticipate Sontag, for a wide
variety of reasons, in this rejection: the bulk of them—not all of
them—make no attempt to reproduce reality, it seems to me,

Les Krims. Aerosol Piece, 1969.
Photograph 4 ¾ ″ x 7 ″. Courtesy The Light Gallery, New York.

Eugène Atget, *St. Cloud,* 1926.
Photograph, 8½ ″ x 7 ″. Collection Abbott-Levy, The Museum of Modern Art, New York. Partial
gift of Shirley S. Burden.

Clarence John Laughlin. *The Search for Identity (No. 2),* 1950
Photograph. Copyright © 1973 by Clarence John Laughlin.

Ralph Eugene Meatyard. This photograph has no title or date.
Copyright © 1974 by Aperture, Inc.

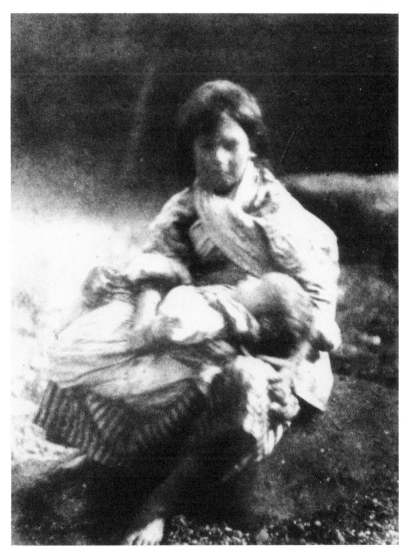

David Octavius Hill and Robert Adamson. *Newhaven Lass with Baby*, c. 1843-1848. Calotype.

although conventional criticism would have us believe that they are realistic. At the very beginning of the medium, the photograph often naïvely confronts or appears to capture reality, particularly when its intent is journalistic. As time passes, however, we find ourselves increasingly in the grip of a vision that honestly admits its selective, deceptive, and entirely personal angle. The very recent emergence of serious interest in color photography is a consequence of the attitude I am trying to describe. Color was avoided by the masters of the years prior to the last war because it was considered by everyone—including journalists and magazine editors—to be "unrealistic." Now, with the acceptance of the notion that the camera lies as sweetly as the brush or the pen, younger photographers are making full and mischievous use of color. I might add that these photographs follow no specific chronology. They document a change of attitude rather than history itself.

I have gathered these images here not to impress or entertain; they are here to provide a visual counterpoint to certain themes I am trying to raise. Although it is the briefest of samplings, for example, the complete desertion of the camera as the instrument of objective truth is resoundingly clear. Virtually all of these images were explicitly focused, arranged, lit, or titled to provide a conscious and personal effect. The pictures by Krims, Meatyard, and Laughlin were staged and performed for the lens, without pretense. Even in the journalistic or documentary photograph—I am thinking particularly of Arnold Genthe's Chinese merchants—there is in the choice of gait and moment an obsession with the specific incident, upon which we base larger generalizations at peril, against the grain of what we actually see.

But there is more here than a simple desertion of craftsmanship and finish, in the service of proclaiming a rugged honesty. Much of this photography has about it the stamp of time, of the fleeting instant during which the lens opened and admitted the light from

the outside world to fall on the sensitized film within. At least there is no attempt to pretend that the image exists perfected, beyond decay, and outside time. At this point we are nearing the magnificent and terrible appeal of photography, which is anchored in the infinite complexities of time, and our experience of time. Fox Talbot, one of the first photographers, felt it in 1841: "But a single shutter standing open projects far enough," he exclaimed, "to catch a gleam of sunshine!" It is long past time for us to marvel at the mechanics of this invention, but I am convinced that this miracle still tingles within us, suppressed by 150 years of education, preparation, and propaganda. I have a reproduction of an old photograph taken by Atget, hanging in my loft; he took his camera one morning fifty years ago to a park in Paris and literally photographed the mist of daybreak, which hangs lightly over the lake sighted in the distance. My formalist friends—indeed, all my friends (and a few enemies)—stop in front of this photograph, and talk of its marvelous composition. Others debate the size and make of the camera and the time of exposure.

And well they might. For to talk of its real meaning, locked into an evaporated moment, day, morning, year, and man, is to touch upon real terror, the terror that is implicit in your mortality, in mine, in countless poems, paintings, monuments, religions, and perhaps in the existence of culture itself. Photography constantly forces us toward a confrontation with that awesome reality. It has often been said that every photograph mediates between art and science, between metaphorical and specific truth. I prefer to say that the pictures here illustrated mediate between an unreal fixed time and the real, moving time that sweeps through us at every instant, including this one. Even in the most contrived of these pictures—that is, in the best of them—there is the touch of a specific point in time. We know, or sense, that Krims's couple conducted their spraying exercise on that day in that room, with the light falling just so on the stomach of the standing victim (or is the real victim

on the bed?). We know that at a given second in time the man in Meatyard's photograph moved his head, on cue, against a slow exposure, creating a blur in the lens which—despite its abstract effect—is a lost human act. The woman looking into her mirror on the street in Laughlin's photograph is no longer there, nor was she a minute after the lens shut.

Both Duchamp and Benjamin have claimed for art (or painting) an immediate aura or personality that is strongest as its point of conception. The photograph gains its aura as it recedes into the past. Perhaps you feel this when you see old and "primitive" photographs. They become more attractive to us in their eroded state than they were when they first appeared—fresh and brilliant —from the developer's hand. Indeed, we cherish imperfections such as those that disfigure Hill and Adamson's *Newhaven Lass,* for example, since they bear the unmistakable hand of time, while they abort accuracy and clarity. Recall now Meatyard's blurred face, which is in itself a primitivistic mark, as if he—and many younger photographers working now—wanted to lose his picture in time as soon as it was made. That is to admit a startling fact: Photographs grip us in proportion to their distance from pictorial perfection. Which is another way of saying that the photograph is best understood not as an object, in the esthetic sense (I have already granted that it is an object in the capitalist sense), but as a disembodied image, hung in the mind.

Let me pursue this thought a bit longer. John Szarkowski has written somewhere of photography's "strange alliance with time and chance." The reason the alliance seems strange, to all of us, is that the instant stands still before us, in our hand, as though fixed forever. But the formalist and purist mistake is to assume that we are affected only by the presence of that glossy (or flat) piece of paper; both eye and hand are joined in the effort of perception by the mind. We know when we see a photographic image that it has come to us from a departed point in time. The photograph may not physically move on, as do film and particularly videotape, but

our minds move. Both mind and photograph engage each other and move from each other in the same instant, one into the future, the other into the past, in a perfect irony. Paintings are masters of their moments, imposed on time; photographs are servants of time, and in their presence we are reminded of ourselves, and our own servitude.

I don't pretend that my words can clarify these paradoxes resident in the medium. But our irrational attraction to the pathos of passing time is not a subject that comes easy to explanation. No discussion of photography's claims upon us can avoid it, however. Photography is equally captive to its content, as seen in that split instant of recording on film. Sontag quite rightly rages against the easy liberal-humanist response to photographs describing human suffering and brutality: to regard them as metaphors, as generalized lessons on the horrors of war and disease, is to look blind. But the cause of this blindness is in the culture, not in photography, particularly not the kind we have been studying. Here was no striving for metaphor. Here are specific bodies, specific faces, specific acts: you will note how often the titles are flat, factual, and detailed. What is being authenticated is not the world beyond the window but the window itself: the content presented to us in that lens at that instant in time. I read recently that Clement Greenberg himself stated in a lecture some years ago that a formalist approach to photography is impossible, since the medium is laden with content. By that I am afraid that he meant the photograph as mirror to reality. That is not what I mean. I am talking about photography's link to the reality of the instant in which it acts, which is an abstraction from a larger time, and context. Eugene Smith's photograph of Tomoko and his mother is a specific, defined, and human reality; the tragedy of the doomed village of Minimata, all of its mothers and all of its children, is something else, beyond the scope of our minds, and this picture.

There can be no new approach to the making or understanding of photography save through specific time and specific con-

tent. Which is the same as saying that these flat, fixed images
act like floating images in our memories, rather than as objects.
I ask any of you to recall the size, medium, or form in which
memorable photographs first came to you. Unlike paintings,
which are by definition objects, photographs dart in and out of
our eyes and hands in dozens of shapes, through newspapers,
magazines, snapshots, reproductions, slides, television, film, and
even—once in the rarest while—in the form of an artist's origi-
nal print. Photographs, to repeat, are closer in their nature to
slices of visual memory—and therefore to the instincts deepest
in ourselves and our culture—than almost anything save life ac-
tivities themselves. The meaning of the photographic image,
then—like the meaning of the books we read (the size and
shape of which we can never recall, either)—lies within its own
dematerialized self, beyond form. Forget all the learned babble
about photographic means, methods, and rules as you think
about the images we have discussed. Think of them as mes-
sages, not as mediums. Forget the medium.

By now I must sound especially perverse, perhaps even anti-
photographic. Certainly I am arguing against the mechanistic
and purist interpretations of photography, and in the process
against that habit of mind in all the arts. I am contending that
photography at its finest is a product of our culture, not a win-
dow on the culture. The photographic image should be read
and judged exactly as we read and judge moments in life, if
not art. But this adversary position means no ill will to photog-
raphy itself. I repeat what I said before: that photography now
enjoys its largest and most engaged audience at precisely the
moment when it is deserting pictorialism, perfection, and illu-
sion for a rough and candid, split-second reality that is itself an-
ti-"photographic" (defined in the traditional sense). I remind
you of Man Ray's remark, a favorite of mine: "A certain
amount of contempt for the material employed to express an
idea is indispensable to the purest realization of this idea." If

we are armed with the proper contempt—for the imperial claims of photography as truth—there is no way it can lie to us, or we to it.

Which brings me truly around to where I began, with a question that pretended to be about Robert Kennedy but was in fact about the meaning of photography, and of time. If the first photograph is a fugitive of time, so is the last. Each one is an image, residing only in itself, and in the moment of its conception. The last photograph is a messenger from and an image of that moment, passing through the lens. This is all the viewer can or should expect it to be. The game of photograph-upon-photograph is an exercise in the limits and glories of the medium, purposely anchored in a depiction of an event known to and believed in by all of us: a super-real event. The last photograph is, yes, a photograph of that instant, and clear in its derivation because it is essentially blank, without the complex tension between realism and abstraction that is the inevitable condition of the medium.

NOTES

1. *Print Collector's Newsletter,* Vol. IV, No. 3 (July–August 1973), pp. 54–60.
2. For purposes of time I am passing over an important qualification: that many photographers feel the proper medium for the dissemination of photographic images is not the collector's print—which serves as a source of basic income—but book and magazine reproduction. I agree with this position, in photography as well as in videotape, where broadcast serves the function of reproduction.
3. "The Territory of Photographs" and "Meatyard," *Artforum,* November 1974, pp. 64–73. "Photography: The Coming to Age of Color," *Artforum,* January 1975, pp. 30–36.
4. *New York Review of Books:* "Photography," October 18, 1973;

"Freak Show," November 15, 1973; "Shooting America," April 18, 1974; "Photography: The Beauty Treatment," November 28, 1974; "Fascinating Fascism," February 6, 1975.

5. "Photography: The Beauty Treatment," *New York Review of Books,* pp. 35–39.

6. Douglas Davis, "Is Photography Really Art?" *Newsweek,* October 21, 1974, p. 69.

Filmgoing / Videogoing: Making Distinctions

THINKING ABOUT THE DIFFERENCES between video and film—
which is nothing less than thinking about the essences of each—
must begin in the experience of seeing. What we see depends
upon how we see, and where, and when. There is the experience
of going out to see a film, an experience that begins early in our
lives, with the approach of the theater marquee, the press of the
crowds, the seat found in the darkness, and then the huge, over-
powering screen, larger than any imaginable life, images as big as
a child imagines a building to be. Later the act of perception takes
place in a dwindled space, brought on by reaching adulthood, and
by the change in taste. The screen may be smaller, the noises
around us less exuberant, but still we have gone to this space, gone
out to sit in the dark before large, moving images. We go "out" to
see a painting or a drawing, too, to a public place, to a museum
or a gallery, or a cathedral. Since the nineteenth century, how-
ever, since the growth of an audience that could purchase works
of art and hang them in private spaces (instead of an audience
limited to princes and cathedrals), we have seen in these museums

First published in *AFI* (American Film Institute) *Report,* May 1973.

or galleries works intended for small, private spaces, for city apart-
ments, and suburban homes. We see them even in the public
museum in environments grown increasingly intimate; we focus
in upon these images in light directed so as to draw us further
inside them; we focus, stand, and then move on, noiselessly, from
one work to another, in control of our own time. The scale of man
to image is equalized, particularly in this century, when the epic
or public painting has only lately begun to appear again. And then
there is the experience of seeing video.

Think about this act, this totality of perception. It falls some-
where between the experiences I have just described, between
film and painting. A small screen, lit from within, its moving im-
ages paradoxically built, as E. H. Gombrich points out, on the
physical limitation of our vision; our eyes cannot keep up with the
luminous dot that sweeps continually across the inner face of that
tube. We do not go out to see video. We turn it on without any
sense of occasion; often, indeed, we turn it on unconsciously and
leave it there, the images moving across the screen, the sounds
emerging from their tiny speakers without our knowing. The
focusing, as in painting and drawing and sculpture, is inward, onto
something. (While watching a film, the eye looks up and out; the
mind is drawn helplessly away from itself, into a larger-than-life
existence.) We give video our attention, not the reverse; even in
moments of absorption the screen is left without compunction, for
a drink, a phone call, an errand. There is no one around me,
usually, that I do not know. Often I am alone before the screen,
as I might choose to be alone before a painting. Yet there is a felt
link to some larger consensus. The viewer is alone but he knows,
subconsciously, that he is part of an audience, whose remaining
members he can neither see nor hear.

The video experience is not, I am trying to suggest, a simple
experience. It has affinities with film, painting, and theater, but
there are as many contradictions. Even the experience we know,
difficult enough to understand, is changing. Television screens are

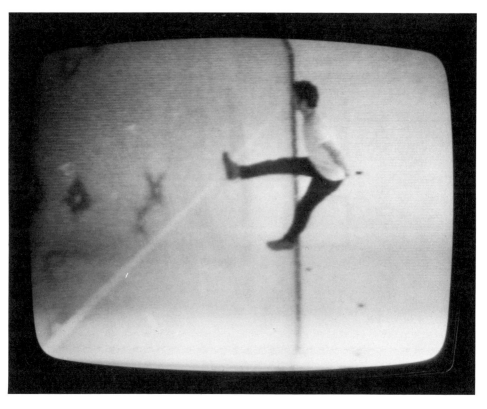

Bruce Nauman. *Slow-Angle Walk,* 1969.
½″ videotape with sound, 55 minutes. Courtesy Castelli-Sonnabend Tapes and Films.

growing larger; audiences are becoming lonelier, more in-
dividuated, thanks to cable television, half-inch videotape, and
video cassettes, all of which provide specialized programming
choices. Our attitude toward the screen—of which this essay is a
part—is becoming more self-conscious. Even so, it is clear that
video's affinity with other media, and particularly with film, is
conditional. *How* we see it, physically and psychically, is the major
condition. Film performers, seen on the street, carry an aura; they
can overpower us, in real life. Video performers remind their
public—when seen in the street—of next-door neighbors; we
reach out to shake their hands instinctively.

If I seem to be describing a medium that is less iconic in its
nature than film, remember that I am doing so from a basis in
perception. If we are going to capture video as a medium for high,
difficult, and intense art, we will do so only by utilizing it for its
own sake. Artist, critic, and public must act on the certain basis of
how video is seen. The painter does not need to think this issue
through; he knows (without knowing) the perceptual system into
which his work will fit. So does the filmmaker. From the earliest
age he is engaged in that perceptual system. We are all moviego-
ers first, even those of us who were weaned on video. For televi-
sion has not yet been defined. From its inception, it has been
controlled by men and women forced to pay for its existence by
reaching an impossibly wide audience. We have not seen video
yet. Television until now has been made by sensibilities condi-
tioned in popular fiction, film, and theater. I cannot think of a
completely equivalent case in the history of the arts. It is the case
of an enormously rich and potential medium coming to birth in
the hands of people forbidden (by economics) to discover its es-
sence.

This is precisely why artists untrained in either television, film,
or the theater are beginning to show us more about video than
we've yet dreamed of. This awakening has nothing to do with the
technology of half-inch videotape except insofar as its appearance

made personal investigations possible, as the arrival of the easel painting (as distinct from the frieze or the fresco) made another art accessible. It has to do with thinking afresh, looking at video for the first time. I cannot stress too much the necessity of this freshness. When I talk to students about video I always begin by asking them what "television" is (because I don't know myself) and we always conclude, at the end of the session, that we aren't sure of very much. The more I work in it, the less I know. Nam June Paik once told me that he always discovers more in his work when he sees it broadcast than he put into it. James Rosenquist once refused to work in experimental video because the screen wasn't large enough. "Come back when it is at least three feet by five feet," he said. He brought the conditions of painting to bear on what he saw, as a filmmaker might, who fills up the tiny screen with epic-sized images. There is nothing more intriguing to me than the size—and the variety of the size—of the video screen. I once telecast on cable in New York City a color tape *(Studies in Color Videotape II)* that focuses upon a moving red light image at the very end. Depending upon the size, shape, and nature of the receiving set, the viewers saw many different lights, in some cases highly luminous, multicolored images. The reactions depended on the condition of the set, which is a condition of the medium to be faced and used, not denied.

Let me return again to where and how we see video, to catch it there in a very special moment. Alone once more, in the home, not formally seated, or surrounded by large numbers of people. In that moment, we can also be connected to the uncertainty of real life. Film is always prepared for us, its time telescoped by the making hand. In the theater we inhabit the same time in which the players perform., but we know that the next step, and the step after that, has been predetermined by the playwright. What we have come to call "live" video links with "life" in a highly concentrated form; when we are watching "live" phenomena on the screen we participate in a subtle existentialism. Often it is so subtle

that it nears boredom. Yet we stay, participating. The endless moon walk, the endless convention, the endless (in another way) *An American Family,* an open-ended *verité* documentary of a California couple telecast by the Public Broadcasting Service in 1973. In all these cases, the "live" dimension kept its audience there, before the small screen, alone, at home, waiting, because it knows that anything may happen next. I mention *An American Family* deliberately; though edited, it made less attempt to structure and pace narrative events than any popular television series yet. Often long stretches of meaningless, boring conversation were allowed to play out, unstructured. "Live" time approached life time. For this reason, and because we knew the *Family* was "real," we stayed, waiting, aware that something unpredictably "live" might occur next.

Video is not life, of course, any more than any art is. Unlike the other arts, though, it approaches the pace and predictability of life, and is seen in a perceptual system grounded in the home and the self. I do not know how we moviegoers are going to understand this, thoroughly, but we must. The link between the formal occasion that is film and the private occasion that is video must be both recognized and forgotten. There will be no video art until we approach this medium as if it had not existed before.

The Decline and Fall of Pop: Reflections on Media Theory

MEDIA, n., pl. of MEDIUM. 1. That which lies in the middle. . . . 2. A substance through which a force acts or an effect is transmitted. . . . 3. That through or by which anything is accomplished. . . .
—*Webster's New Collegiate Dictionary,* 1961 edition

THIS IS AN ARGUMENT bound at one end by two anecdotes and at the other by a very short story. The first anecdote may well be apocryphal. I am told that in discussing media before the annual meeting of the American Association of Museums in Los Angeles, Charles Eames, the architectural laureate of the slide-and-film installation, stated: "As for media, I sometimes wonder whether you (that is, the museums of America) should be involved with them at all." To which there was tumultuous applause. This incident has often been related to me—correctly or not—by museum professionals who falsely assume that I will be instructed by it and cease calling for them to use media (which is in turn based upon another false assumption: that I ever called upon them on so general a ground in the first place). Certainly, the incident ought to

Originally presented as a lecture for the Northeastern section of the American Association of Museums at Winterthur, Wilmington, Delaware, November 1976.

be true, if it isn't, for reasons I will shortly explain. The second
anecdote I know to be true because I was there. It is an important
conference to discuss ways and means to fund experiment in tele-
vision. Most of the guests are executives and producers drawn
from commercial or public television. The lone exceptions are
myself and Nam June Paik. We both argue in very different ways
in behalf of cable television—that a dollar devoted to this exceed-
ingly low-cost and time-rich medium will produce many more
hours of actual experiment (in terms of broadcasting) than a dollar
flushed down the hideously expensive drain that is the networks
—and PBS, now itself a big business. Of course our colleagues
disagree. They argue that commercial television can be reformed
only by producing another, but "superior" television program, in
prime time. When I argue (with Paik) that this will simply dispose
of millions of dollars very quickly and not change the decision-
making structure of commercial television at all, I am countered
with statistics—astounding figures, purporting to show that the
small CATV audience is irrelevant, if not invisible, compared with
the massive audiences commanded by the networks. "We have to
go into prime time," says a colleague, sitting to my immediate
right. "That's where the tribe gathers, around the TV set."

These anecdotes are directly connected. The first is a conse-
quence of the second, as is the undeniable disillusionment among
museums with the efficacy of using new media as exhibition tools.
They are the consequences of a flawed premise, buried deep in the
bowels of conventional media theory. Most of what I have to say
here is directed toward defining that flaw, rather than sketching
out a blue-sky future, in which the museum audience merely sits
at home, dialing in holographic reproductions of the major works
in its collections. There has been quite enough of that, supplied by
the futurists of art, science, and popular literature. What is needed
now as we think about the future and move toward it simultane-
ously is a dash of pessimism, seasoned with some radical rethinking
of certain beliefs, assumptions, and styles foisted upon us during

the last decade. This sort of thinking can do more for us, in terms of immediate projections, than one more visionary blueprint of tomorrow.

More important, the flaw I mean to discuss is so complicated, so deeply entwined in our thought processes, that it will be at least a decade before it is rooted out. I use the word "Pop" in my title because I believe that it best defines the cast of mind—or sensibility, if you prefer—that is in error. But I mean by that much more than "Pop" art, which had its historical moment some years ago. I mean a closely related body of ideas that can be found not only in media theory—most particularly McLuhan's—but in formalist and even post-formalist art criticism, in the early vintage essays of Susan Sontag, in the later architectural theory of Robert Venturi and his school, in the practice of commercial television, most public television, and presidential political campaigns, and in the esthetic lurking behind the "media installations" in most of our major museums. Surely it is surprising to see so many disparate phenomena linked together and that is where the difficulty of my subject lies. There is no doubt in my mind that these matters are closely connected, but we may jointly be too close to them in time to see the relationship; more to the point, I may be inadequate to the task of joining them. But certainly, if we are to move off dead center in the interpretation of new media, the attempt must be made.

Let me begin by defining the one characteristic of the Pop sensibility that concerns me the most (it also happens to be a trait that is widely recognized and understood). In its attitude toward the new media—and indeed the popular landscape of billboards and neon signs—the Pop sensibility is proudly objective and non-judgmental. It eschews whenever possible personal commitment or expression, considering them both to be subjective, egotistical, and even narcissistic. Certainly you recall Andy Warhol's many disclaimers that he had as a person anything to do with his art, which was in fact imposed upon him by the culture: "I want to be

a machine," he told us. Susan Sontag made a more explicit and learned attack upon the cult of the person and of judgmental criticism in an influential book that declared its thesis in its title, *Against Interpretation.* Clement Greenberg argued in his own way against interpretation—literary or political—stressing that a painting existed by virtue of its physical ingredients only, with no causal or moral link to the outside world. Robert Venturi, Denise Scott Brown, and their colleagues say again and again in their book, *Learning from Las Vegas,* that they will have little to do with the social and political content lurking behind the architecture of the strip. "Architects are out of the habit of looking nonjudgmentally at the environment, because orthodox modern architecture is progressive, if not revolutionary . . . dissatisfied with *existing* conditions. Modern architecture has been anything but permissive." And again they write: "For the artist, creating the new may mean choosing the old or the existing. Pop artists have relearned this. Our acknowledgment of existing, commercial architecture at the scale of the highway is within this tradition." In another place, they use the term "people's architecture," with obvious reference to Las Vegas, though they also acknowledge— elsewhere in the book—that the Strip was not made by or for the people but to seduce and exploit them. What the Venturis have said here recalls another of Warhol's epigrams: "Pop art is liking things."

But surely this is a point I do not have to labor with this audience. Among other qualities, the Pop sensibility is markedly indifferent to content and to personality. It accepts what it finds in the world, prefers that to the subjective regurgitation of the psyche, and uses it quite often directly, without comment, as in Warhol's *Brillo Boxes,* or ironically, as in the gold TV antennas placed by Mr. Venturi on top of the Guild House, in Philadelphia. The very phrase "The medium is the message" embodies this spirit. We need hardly comment on the total disregard in McLuhan's writings and teachings for the content of television—what it happens

to be telling us or showing us at this moment rather than at other moments, or in this year, 1976, when the spectrum of choices on our TV sets is five or ten times greater than it was in the 1950s, the decade in which McLuhan developed his theories. This appalling vacuity is known to every self-styled intellectual who prides himself on belonging to a class that definitively rejected McLuhan, in name, some years ago but continues to practice his doctrines with remarkable fidelity. I refer now to the press and particularly to its performance during the past campaign, when we found time and again the course of the campaign being analyzed in terms of its packaging rather than its substance, or content.

This was of course most evident in the press reaction to the Ford-Carter debates: no matter how often the candidates disagreed substantially on federal management of the economy or health insurance, we were flooded immediately thereafter with speculations about who spoke more crisply or smiled more often. McLuhan himself appeared on the *Today* show the morning after the first debate and announced that Carter looked better in color than Ford and that the President should be presented only in black and white. The commentary was focused on the culminating impact of the medium, in other words, not the message. As it was intellectually fashionable to say during the campaign that there were no issues at issue or that there was no difference between the candidates, it is also intellectually fashionable to say that it makes no difference what appears on TV when the mass audience is watching: TV is always TV, in other words, bland, simple-minded, and mentally paralyzing. In this manner, McLuhan—who is no longer radical chic (Tom Wolfe never mentions him anymore)—has won the struggle for our minds. His opponents in media theory, men like Wilbur Schramm, who argued in a long-forgotten book, *Television in the Lives of Our Children* (1961), that the mind reacts to television content precisely as it reacts to print content (the reading varying with the IQ and economic class of the reader), have rather definitively lost. We have subliminally

agreed, with the Pop sensibility, to accept what TV has been as what it must be.

Some readers will now be asking what all this has to do with the issue of media in museums. Where are the hard facts about the economics, the strategy, and the style of installations, here and abroad? But these installations, contrary to rumor, are the result of free choice. The media, new and old, are dumb tools manipulated by the mind, in league of course with the necessities of budget and space. The mind in turn is heavily influenced in its decision-making by what it believes. If I am correct and we have been converted to an indulgent Pop/Ironic view of the media that glorifies its physical characteristics, we will make one set of choices. If we take another point of view, one I hope presently to define, we will make an entirely different set of choices. In 1965, Gerd Stern, one of the most perceptive media-installation professionals, created an environment called *The World*—the first multimedia discotheque—incorporating twenty programmed slide projectors, one film projector, a closed-circuit television projection system with three cameras, and a thirty-foot-high screen. Ten years later, he is making subtle, content-rich environments with modest means, utilizing domelike enclosures that focus rather than disperse attention on a slowly moving stream of images. Something, clearly, has changed, philosophically speaking (the media tools available in the seventies are physically superior to those at hand in the sixties; we could be pursuing more *impact*, not less, if we wished). What we really believe about the nature of these tools and the nature of the audience to which they connect us is where we must begin, if we are to improve upon a situation that is admittedly bankrupt. I could write at length about style, strategy, and cost, and it would not change museum decision-making. I have already tried, as have several of my colleagues. Time and again we urge upon major museums the use of cable television to exhibit our work, via free telecast, into the homes of an audience as large—at least in New York—as the museum-visit-

ing audience. Time and again the decision is to mount expensive, crowded displays of hardware in tiny quarters where the audience can barely move around, much less watch a videotape in focused silence.

Therefore, let me address the McLuhanite case we have subliminally accepted—the view that leads us to accept the media (like paintings) as ends in themselves, beyond our conscious control and transformation. We need to be reminded of the central tenets of this case from time to time in order to see how fragile they are. The idea that McLuhan seems to have pressed most successfully upon us is that we are being moved by television into a sensory-tactile and mosaic culture, which will inevitably draw men together into a "global village" unified by common images commonly perceived (the tribe sitting together in prime time, as my colleague said). What is being left behind, he told us a decade ago, is the linear, fragmented, and individualistic "print culture," bequeathed to us by the Gutenberg press and the Renaissance, with its inevitable disassociation of sensibility (the mind disassociated from experiential reality by the dependence upon the printed page) and alienation. If you think I am oversimplifying the argument, read on—read McLuhan's words, in fact: "Literacy gave man an eye for an ear and ushered him into a visual open world of specialized and divided consciousness" . . . "Nationalism came out of print" . . . "The assembly line of moveable types made a product that was uniform and repeatable as a scientific experiment" . . . "Our new electric technology that extends our senses and nerves in a global embrace has large implications for the future of language" . . . "Electric technology does not need words" . . . "TV is above all an extension of the sense of touch, which involves maximal interplay of all senses" . . . "TV creates total involvement in all-inclusive nowness" . . . "TV has transformed American innocence into depth sophistication, independently of content."

I think it is fair to say that this catchy, colorful theory took deep

root in the visual arts rather quickly. The way had been prepared by formalist theory and the artists it explicated and defended—in the work of Pollock, Kline, certain aspects of Newman, and all of Olitski, the medium is indeed the message—and by the necessity to ward off the social-realist denigration of abstraction. But it also flattered the artist and the architect, because it placed him in the center, if not the forefront, of a new culture: "Mastering the . . . transformation of time into experience is one of the main jobs for the man of the new culture," wrote Caleb Cattano, a disciple of McLuhan, in his 1967 book, *Towards a Visual Culture*. "When those who understand that television is a pre-eminent channel towards the visual culture are heard, they will display in their being the characteristics that will make them . . . capable of generating change . . . hence the formation of an elite of the new culture . . . who know television for what it is." I might add that not the least element in this appeal was its corresponding disdain for the old-fashioned fogies still chained to the print-based, humanistic culture.

There is abundant evidence of the excitement caused by McLuhan's theories and prophecies throughout the last decade. But for purposes of time, let me quote the fine architect John Johansen, who responded perhaps more thoughtfully and certainly more directly (his style changed markedly during this period) than anyone else:

With the passing of the industrial age, we may now expect an architecture conceived more as a computer, of components rigged on armature or chassis connected by circulation harnesses. . . .

Historic revival—neoclassic and neobaroque opera houses and museums, neo-medieval castles to house factories, neo-Gothic dormitories, and the "mono-pitch school"—is out-of-date. The air terminal that looks like a bird, the "architecture of imagery" is out-of-date. And since the mechanical age has been replaced by the electronic age, buildings styled after machines are out-of-date. Those who do not derive their forms from the experience of our present environment upon our changing habits of perception are out-of-date.

The experience we derive from our buildings will be drawn from a fusion of the senses; the impact swift, instant, condensed, total; the message immediate, direct, possibly crude, unedited, unrehearsed, but real. Textures of exposed finishes, for example, allow us to feel with our eyes from a distance; or we see with our sense of touch.

Finally, Mr. McLuhan's observation that "the medium is the message" has its parallel in architecture. This simply means that the influence of the vehicle by which the message is sent is greater than that of the message itself. Correspondingly, the building as an instrument of service has greater effect upon our lives than the functional service itself.[1]

For a moment let me pass over the broader implications of this prophecy and concentrate on the adjectives used by Johansen to describe the experience of the new post-industrial buildings: "swift, instant, condensed, total" . . . "direct, possibly crude, unedited." It should bring to your mind a similar experience associated with a totally different source: the mixed-media and multimedia exhibitions foisted upon us by many of our major museums in the late sixties (and even to some extent today). From the *"Kunst-Licht-Kunst"* exhibition at the Stedelijk in Eindhoven in 1966 to "The Machine: Art as Seen at the End of the Mechanical Age" at the Museum of Modern Art in 1968 to "Art and Technology" at the Los Angeles County Museum in 1971 there is a determination to shock and confound the viewer with a multiplicity of mediums that exceeds even the raw power of Stern's *The World* or the most vulgar of the rock-strobe discotheques. The gently rocking *Grey Computer* of Edward Kienholz sits in metaphorical company with the thundering clang of Len Lye's shimmering metal loops. Robert Rauschenberg's heaving and bubbling bed of mud *(Mud Muse)* lurks around the corner from Roy Lichtenstein's kinetic paintings. Works of differing philosophical intent and generic form are perched side by side with an abandon that would simply not be allowed when installing a group of paintings, photographs, or sculptures.

I don't have to tell you what the results of these and similar exhibitions were: high attendance, critical dismay, and public dis-

taste, rather like a handsome slice of chiffon pie that—once bitten —turns sour on the tongue. The proof is similarly clear: none of the museums I mentioned above ever again mounted an exhibition remotely like *The Machine* or its allies, with the possible exception of MOMA's "Information" show in 1971, which dealt with conceptual art in an equally unfocused, everything-at-once manner, as though art as idea deserved the same treatment reserved (I think unfairly) for art as light or art as motion.

What philosophy of perception, of media, or of audience psychology lay behind these monstrosities? The least we can say at this moment is that their organizers presumed (with McLuhan and his followers) that the value of the work they mounted lay in their means of expression and nowhere else; beyond that, the individual segments within the installation had nothing inherent or integral to impart to the audience—rather, the message lay in the whole or the mass, impacting (as Johansen would say) "swift . . . condensed, total." Such an assumption would not be made about painting or drawing, but neither of these "substances" depends for its definition and understanding upon so shallow and unreflective a theory.

Though we no longer encounter *The Machine* genre of exhibition, it would be wrong to think that the compulsions behind it are extinguished. I myself have been jammed into more than one video exhibition in which monitors compete with each other side by side. I found myself, for example, in France playing on a monitor located—with other monitors—in a hallway that linked two noisy, competing mixed-media installations. It was an exceedingly narrow hallway, with no place to sit or stand. When I complained to the curator, he explained that it was in fact a place of honor, since thousands of people passed through the hall each day— never stopping, to be sure, but passing by, for what that was worth.

This sixties theory has sifted down to its lowest common denominator in the Living History Center in Philadelphia, which opened in 1976. It is rightly advertising itself as the most advanced mul-

timedia installation yet known—the artifactless museum at last. The center is jammed with electronics: audio pipes, each one telling a story or singing a song of its own, are suspended from the ceiling; a kaleidoscopic theater reflects moving images via mirrors into infinity; perhaps the most complex slide show ever programmed flashes 2,500 slides on 64 screens, and historical images march across the world's largest movie screen, a 70-foot-by-94-foot Imax. I defy any of you to pass through this thicket of electric technology and emerge with a single idea intact. Though the opening installation purported to tell the story of American history, it told only about itself. Here the electronic emperor is in full sway, stripped of any pretense of serving an end beyond itself. When I protested to one of the organizers that no child or adult could emerge from this horror house with a shred of coherent information, my attention was drawn to a child listening to an actor read aloud the Declaration of Independence to him via telephone. "This is much better than showing him the original document," she said. "He would never read it."

Let's pause and think about that just for a moment. Yes, the act of reading such a document requires more from the viewer than lifting a telephone. But the question is: Are we interested in communication—of the message inherent in the document—or are we interested in media contact alone? I don't propose to answer the question now, simply to ask it. There is no doubt that many people will pick up a telephone and listen—or try to listen—to a tape-recorded voice. But what can they hear or retain in such an atmosphere? What is our goal—to transmit ideas or to place the seductive crook of the telephone into a hand?

It is extraordinary that such fundamental questions are rarely asked of strategies like those in evidence in Philadelphia. But this is a natural consequence of something even more extraordinary: the failure to ask for proof of the McLuhanite gospel that spread so rapidly and uncritically through the visual arts community in the past decade. After all, we now have between ten and twenty

years of results to consider, depending on the date of any one of McLuhan's stream of books, articles, and pronouncements. If we are indeed on the way to a new and tribalized culture, we ought to be able to notice some significant changes, particularly because we witnessed in the last decade the rise to public notice of the first generation of young people entirely weaned on TV. How did they behave? Can we say that the sixties—taken as a unit—showed us a culture coming together, discarding print, discarding individualism, resolving differences?

Well, you know the answer. The very least we can say is that the impact of television upon our youth is decidedly complex and unpredictable. The most we can say is that the post-TV generation displays more of the damnable characteristics of a print culture than the pre-TV generations. I submit that the culture we are living in is alienated and skeptical. It is exceedingly irreverent toward authority—I remind you of LBJ hung in effigy during the antiwar rallies and the T-shirts marked "Nixon Knew" that began to appear during the early days of televised Watergate hearings on PBS. This "TV culture" seems to disbelieve a great deal of what it is told—about products (the consumer movement is a recent phenomenon), about corporations (every poll tells us that the public suspects their role in the oil crisis), about government policies, about political leaders and their promises. Unlimited access to prime-time television did not aid Nixon's case in 1973 and 1974. There is—to go on—no substantial evidence that TV has destroyed the appetite for reading, a fact predicted in Schramm's neglected study, in which he argued that children "leave" television between the ages of ten and thirteen as a steady diet, replacing it either with print or with social activities, depending upon their IQ and environment. Meanwhile, the need to preserve ethnic identity, customs, and language has if anything heightened in the past decade. The tribe that gathers in the millions between 8 P.M. and 10 P.M. does not gather to worship what it sees and hears.

In this regard I commend to you an important new book enti-

tled *The Unseeing Eye: The Myth of Television Power in National Elections,* written by Thomas Patterson and Robert McClure, two political scientists from Syracuse University. It is filled with tables of statistics drawn from intensive polling—the modern equivalent for quotation from Scripture during the Middle Ages—proving to the decimal point that the voters make up their minds from a multiplicity of sources, only one of which (and hardly the most trusted) is TV. There is even evidence in the book that the voters care about issues—content—and that they divine the differences between the candidates on the basis of reading newspapers, because they can't get this sort of information from commercial television. After the disgraceful performance of the electronic media in the 1976 election, when it barely paused to define either candidate's position on anything, I should think that this trend will continue.

What about the confident predictions that the arts, including architecture, will turn away from their embarrassing and elitist involvement with ideas, subjectivity, symbol, meaning, and historical reference? Once again, a skeptical observer has every right to conclude that the reverse of these prophecies has occurred. The most influential artist in the world in the early seventies was the German Joseph Beuys, whose work is redolent with a personal, romantic trademark and a thorough commitment to political action—through his political party, the Organization for a Direct Democracy. He is the antithesis, symbolically, of Warhol. At the very moment that some of my prophets were speaking and calling for a new visual culture, conceptual art was on the rise, soon to be followed by "story," or narrative art, a movement whose physical embodiment is almost always devoted to word and text, not to image. At this moment, we are passing through a period of intense concentration on the self (in painting, drawing, performance, and video), verging on the autobiographical and narcissistic. The major magazine of contemporary art, *Artforum,* once a formalist bastion, is now radically different, engaged in the discussion of politi-

cal issues—such as the sale of the Pasadena Museum to collector Norton Simon—that were once considered beyond the province of art writing. In architecture, I am sorry to have to tell my friend John Johansen that the building as meaning, metaphor, and even history is definitely back with us, in full vigor. Many younger architects are attempting consciously to deal with the personal house as meaning. In its determined reference to the past, the work of Robert A. M. Stern is a further indication that Venturi's earliest theories, based on what he then called "the richness and ambiguity of modern experience"—enunciated in *Complexity and Contradiction in Modern Architecture* (1968), before Las Vegas and the cult of the "ordinary"—are remarkably and truly prophetic.

If you will not agree with me that the attitude I defined at the outset as Pop/ironic has been astonishingly wrong on a number of counts—particularly as it is reflected in McLuhan's theory of media—you must certainly concede that it has serious flaws, as a plan of action and as a prophecy. Why is this so? I think there are two basic reasons, each of which needs to be clarified—briefly— before we reach a conclusion and the final anecdote that I promised you in the beginning. First, McLuhan and his allies seriously misread history. Second, they misread the nature of the medium —television—they depend upon most. The difficulty—the softness at the core of this position—begins with McLuhan's concept of the "Gutenberg Galaxy," bequeathed to us by the printing press. It is of course ludicrous to base any theory of the history of media on the fragile assumption that the mere appearance of movable type radically marked off one stage of human consciousness from another. McLuhan attributes the evils of industrialization and the Reformation to the Gutenberg press, conveniently ignoring heaps of contrary evidence that point to a much more complicated transition. These include the existence of block printing before Gutenberg; the reverence with which written documents have always been held in Western culture (the Magna Carta, the foundation for

our democratic institutions, was *written down* in 1215); the obvious political link between the rise of capitalism and the rise of labor-saving inventions, which did not proliferate until the fifteenth century; the rise (not the decline) of general humanistic learning in the Renaissance, the antithesis of specialization.

Finally, it was not simply the existence of books that felled the metaphysical system imposed by Aristotle and later by the Church. It was the press of events—Columbus's voyage around the world, the horrendous and disillusioning plagues that swept Europe at the end of the fourteenth century, the libido of Henry VIII. In fact, I am feeling so perverse now that I would like to suggest that the proliferation of books and prints—with their multiple and often variant interpretations of reality—rendered possible an experiential relationship with the world (the kind McLuhan is always recommending), not impossible, for they encouraged the single mind to invent yet another interpretation—its own.

The notion that a "print culture" once existed and is now dying, to be replaced by a "visual culture," with completely opposite values, linked in some manner to a pre-print, Catholic culture, is —in brief—absurd. The truth is, as always, far more difficult to state than that (which is why the truth is so often unpopular). Let me hazard a try. Both of these cultures have always existed side by side—that is, the instinct to write and read, away from the world, in meditation; the instinct to draw, to see, to embrace the world, and to perceive through the senses. They are in fact within us, as eye, mind, and senses are yoked to each other. If my little paradigm makes any sense, it explains why McLuhan's assumption that television will work wondrous changes upon us by reason of its very existence is wrong. Because television is subject to the same restraints and limitations that anchor any medium of communication: it must begin and end in the human mind. When Chomsky talks about the "deep structure" of language—how it is inevitably framed by the conditions imposed upon it by the mind —he is talking as well about the deep structure of television, or of

drawing, or of painting. Has anyone noticed that the TV set does not program itself? We program it—in all our strangely variant moods, and capacities; often badly. We also receive it—in all our variant moods; often perceptively, more often stupidly, always perversely, like the audience Duchamp had in mind when he claimed that the work of art is always completed by its viewer, not itself, in unexpected ways.

By itself, television can do nothing, as Gutenberg's press could have accomplished nothing without a Galileo to print. The role of content in television is as crucial as its role has been at any time and with any tool, I'm afraid. No, Mr. McLuhan and friends, it is the message that is the medium. His mentor William Ivins knew that, when he waxed enthusiastic about the importance of the exactly repeatable visual statement in his great book, *Prints and Visual Communication.* But please attend the difference between Ivins and his student. Ivins believed that the repetition of image and print information was important to civilization because it distributes information—not because it distributes itself. When Vesalius block-printed his anatomical diagrams in Rome in 1538 for distribution to his students, he did so to spread a specific body of information. It is content and content alone, then, that can be revolutionary. A television program that reaches millions of viewers and sings the conventional virtues of suburban life will leave as much trace on its time as a Christmas card, while a book written for an immediate audience in the hundreds—*Das Kapital* comes to mind—or a work created for cable television can change a culture. According to Messrs. Patterson and McClure, George McGovern lost the 1972 election by a landslide not because he smiled too much on TV or too little. He lost it because he was on the wrong side of the issues—the voters *disagreed* with him. Carter won on November 2 not because he stood straighter than Ford or grinned more broadly, but because he defined an economic program with which millions of voters could identify.

These are blunt and simple truths, but I fear we have been so

carried away with the slickeries and trickeries of form, packaging, and electricity that we have lost sight of them. Let me proceed to another blunt truth, by means of a writer whom I very much admire, Hans Magnus Enzenberger, a German poet and essayist:

It is all too easy to see why the slogan "The Medium is the Message" has met with unbounded enthusiasm on the part of the media, since it does away, by a quick fix worthy of a card-sharp, with the question of truth. Whether the message is a lie or not has become irrelevant, since in the light of McLuhanism, truth itself resides in the very existence of the medium, no matter what it may convey: the proof of the network is in the network. It is a pity that Goebbels has not lived to see this redemption of his oeuvre.[2]

In other words, the notion that TV is itself the issue—not the men and women who run it (which includes us)—removes the burden of personal choice. I noticed in the last days of the 1976 campaign an extraordinary editorial by John Chancellor of NBC News in the *New York Times*. In this editorial, he complains about the pettiness of the campaign ("I have been deprived of my right to a decent election"), of the way each candidate was scrambling to create attention-getting events, rather than discuss issues. There is never a hint in this editorial that either he or NBC News might be at fault for this state of affairs—for their refusal to report or to think through any issue more complicated than the latest slip of the tongue. Were he pressed, he would surely say (as most TV executives say) that the medium does not permit—in its fast-paced movement—the lengthy definition of ideas, and even if it did, the viewers would object.

But I am trying to say that TV isn't itself anything except a blank tablet. We can expand its time parameters tomorrow—you, John Chancellor, myself—by working in and supporting cable television. I am also trying to say that the audience for television is no worse or better than the audience for print, or for painting. The evidence is abundant that the viewers are not mesmerized morons but feeling, thinking, alienated human beings. In fact, there

is no such thing as a mass audience before the television set. There is simply one person, or two, or three, alone at home, watching. This audience is closer in its mode of perception to the audience for a drawing, or a book, than for a film; it therefore offers the same opportunity for responsible dialogue that exists in the "fine" arts, mature mind to mature mind, with neither condescending to the other.

This leads me directly back to the issue of the Pop sensibility and to an alternative theory of media. The sensibility I defined for you at the beginning will not be warmed by what I am saying, for it forces back upon him precisely those cultural chores he abandoned so gleefully ten or fifteen years ago—that is, personal choice and responsibility. It asks him not merely to accept the banality of commercial television or the Las Vegas strip or the Levittown sprawl, but to change it, or at least to try. It asks him to stop liking everything in sight, regardless of its political or social consequences. It asks him not to level down to the presumed limitations of a mythic audience, but to speak with that person on a one-to-one level, as if trading ideas in a conversation.

I like the sound and the connotation of the word "conversation." The alternative theory of media I promised earlier is directly related to them. Instead of thinking of the television set or the slide or the computer as icons for a new culture, I propose that they be considered extensions of the mind, like language, bound by the same laws, capable of the same open-ended activity, and of the same blunders. Seen in this way, the task of the museum and of the curator becomes at once simpler and more challenging. Works of art (or of documentation) that employ new media can be organized, presented, evaluated, and installed as increments in the dialogue of modern art, not as electronic ice cream cones set up to drip enticingly before a childlike public. This also means that they can act on a high level of communication as well as a populist level. The undoubted power of media to reach the new museum audience, defined in the well-known American Association of Mu-

seums report sponsored by the Department of Housing and Urban Development in 1972, can be employed to educate and to elevate, as well as to entertain and simplify. Linking the TV set or the slide to the mind as a premise rather than to the senses (exclusively) sets in motion a long train of consequences all the way down to the way the museum deals specifically and practically with television or the videotape (not by tucking them off in a hallway). It wreaks a change analogous to the revisionism managed in linguistics by Chomsky, when he placed the source of language in the self rather than the environment, where Skinner had attempted to site it.

The television set as a blank tablet. The camera as a pencil. Cable television (in conjunction with the museum) as the publishers. These analogies restore us metaphorically to a view of the new means of communication that is at once sane, restorative, and personal. When that happens we will see the final decline and fall of Pop, which I hope for but do not predict. There is humor and irony in Pop—its saving grace—but its mode of action, as I have said, is passive and accepting. The environment in Pop is the aggressor, man its victim. Let me conclude by telling you a story that flirts with humor (as well as tragedy) and reverses this ratio.

Once again, I'm not sure whether the tale is true, and once again, it ought to be. The story is alive, in any case, all over the world—for it has been repeated to me several times in several lands. It begins at midnight in a little cable television station in the suburbs. The station is owned and operated by one man, like a family store or a gasoline station. Instead of signing off that night, he dollies his lone camera into his office. He sits in front of it for a long time, thinking what to do. Then he remembers that he has to clean out his desk—something he has been delaying for years. So he begins, starting with the top drawer. Instantly he knows he is on to a good thing. For as he rummages through the accumulation of old pencils and parking tickets, he starts to come upon unopened letters stashed away in the heat of the past. A few of them—*mirabile!*—contain checks. There are notes from long-lost

friends, some of them lovers from yesteryear. The man forgets that he is on camera: he is engaged, after all, in a rediscovery of himself. He opens every drawer, examines every shred of paper, every object. Some are thrown away, others are stashed in his coat pocket; a small portion returns to the drawer. When he finishes with his desk, he attacks the old battered file cabinet next to it, bulging with magazines, newspapers, bills, accounts, half-empty bottles of whiskey. By the time he is finished, the first rays of morning sunshine are breaking through his window and falling on the face of the camera. He has broadcast himself for eight hours!

The denouement of the story is that the audience loves it. A few people are drowsing beside their TV sets, wake up to turn it off, and see this man emptying out his desk. They can't believe it; they watch; it grows on them, like a boring, somehow comfortable guest; they call their friends; the word spreads quickly around the little town served by the station. Next day the man begins to get congratulatory phone calls. Later in the week, there are letters. Somehow the news reaches one of the wire services, and his diffident, night-long gesture is escalated to international status. He never repeats it, however. He returns to his humdrum work and is never heard from again.

This is a climactic story for me—and for all of us—whether true or false. More than anything else I am fascinated that the story nowhere contains a hint of the man's motive. This is obviously because neither the tellers nor the hearers of the tale—whoever they are—feel any need to state the motive. They know it. They know *why* he dragged that camera into his office. An analogy is the recurrent fairy tale theme (surviving in all known cultures) of the abandoned or forgotten child, who is rescued by the hero in the end. Nobody questions the motives of the hero: it is *assumed* that a child in distress ought to be aided. It is also assumed in the suburban parable that the man who opened his desk drawers on television did a good thing, perhaps even a great thing. He may be the unidentified hero of post-Pop culture, if not of art. He forgot

he was "on." He behaved before the camera like a free man. Our task now is to follow him, hat humbly in hand.

NOTES

1. John Johansen, untitled essay on McLuhan in *McLuhan Hot and Cool,* ed. Gerald Emanuel Stearn (New York, 1967), pp. 226–235.
2. Hans Magnus Enzenberger, "The Industrialization of the Mind," *Partisan Review,* Winter, 1969, pp. 100–111.

The Idea of a Twenty-First-Century Museum

> Yet such is the bitter specimen of the fruit of that ambitious system which has of late years been making way among us; for its result on ordinary minds, and on the common run of students, is less satisfactory still; they leave their place of education simply dissipated and relaxed by the multiplicity of subjects, which they have never really mastered, and so shallow as not even to know their shallowness.
>
> —John Henry Newman, *The Idea of a University,* 1852

I FOUND MYSELF in Phoenix, Arizona, on New Year's Eve, 1973, far out in the desert, beyond the outer limits of the city, sipping and talking with a friend. We could see nothing before us, outside the house, save one mountain and a very large moon. He asked me, finally, what I thought a new museum should be. I am not interested in running museums, only in observing and working with them when I can. But I allowed myself to be led on by his warm and coaxing curiosity. Before I could stop myself, I was launched on parabolas of rhetoric and enthusiasm. I told him that the energy implicit in contemporary art was carrying itself restlessly on beyond the object, into media, performances, and dialec-

Delivered first as a lecture at the Long Beach, California, Museum of Art, May 1975.

tics that demanded an extension beyond the walls of the museum. I told him that simply displaying videotapes on monitors inside the museum wasn't good enough: that the museum should broadcast itself into the minds of a large and politically alienated audience. I said that art and private life had been growing together ever since the fresco left the wall and embraced the canvas, which could be taken anywhere, and the woodcut, which could go even further. The new museum must think of itself not simply as a repository, a guardian of the past, but as an agent of communication and a solvent in the present. And last, I pointed out that artists were already working here in the desert, cadging and begging land, often with the support only of European collectors, and that a museum here in the Southwest, the newest extension of the United States, should step in and help them, not sit by, waiting for a third-rate Picasso to claim their funds.

My friend, obviously intelligent and discerning—he actually listened through all this—rose when I finished. "I am going to make you the next director of our museum. You can make it the first post-object museum anywhere, least of all in Arizona." I protested that I did not want such a burden—that I would flee from it if offered. In vain; he was going to have it his way. He would telephone his colleagues in the morning. I had previously been scheduled to dine on the following day with several trustees of the museum in question. At the last minute, they called and complained of a strange virus. Other cancellations for other parties followed. The virus swept the city. I have not seen my friend since; perhaps he feels he lost me a job I did not want. If so, he is wrong. He forced a point that needed forcing, and facing, even in the desert. Both the past and the present deserve a museum; occasionally they cohabit beneath the same roof. When they don't they must break and define themselves apart, where now they belong. On New Year's Eve, 1984, the situation will be the same.

What you have just read is a personal account, written shortly after the experience that it narrates (and published in *AAM News* in June 1974). I have let it stand exactly as I wrote it, not only because I haven't changed my mind (I am as pessimistic about the future of museums as I was then), but because leaving it that way —anchored down by a specific time and a specific human event —tells you something about my approach to this subject. I am not about to lay any charts or guidelines, or tell any museum how to conserve, schedule, or organize its staff. I am not competent to do that, and there are plenty of others who are, deluging the public and the museum community with tons of paper. (The prestigious American Assembly at Arden House in Harriman, New York, sponsored by Columbia University, was devoted in 1974 to a conference on "The Future of Museums." It was chaired by Sherman Lee and attended by decision-making representatives of all the major museums. A book based on their predictably solid conclusions is forthcoming.) We can run computers, collect abstract quantities on paper, and define questions at endless conferences better than any nation in the world. Somebody once called us "The Abstract Society" for this reason; I would rather put it in the terms of contemporary art ideology and say "The Formalist Society." But I have determined not to think in either an abstract or a formalist manner. I am going to try to consider the esthetic meaning and political content of museums as best I can, and to make my thoughts as personal as possible—in other words, it is an approach closer to action painting and post-Minimal art than to the formal, reductive ideas connected to the art of the sixties.

It is not only the museum world that is bogged down in bloodless mechanics: so is the whole society, and recent events are beginning to teach us that abstract problem-solving (the kind defined by Noam Chomsky in *American Power and the New Mandarins*) is not the way to solve problems. If it were, we would not have blundered into the hideous mess that is Vietnam, costing all of us —at last verifiable count—thousand of American lives, millions of

Asian lives, and hundreds of billions of dollars, a mistake so vast in its consequences that we will be paying for it for generations (and they call artists impractical!). Certainly there is something wrong with our premises. Nam June Paik told me that the great American mistake in Vietnam was essentially human: we didn't take into account the hatred there for the white man based on the effects of French colonial rule—an experience not duplicated in Korea, for example, where the Americans came as liberators on the heels of Japanese occupation. But of course, human feelings cannot be quantified and laid out on paper. Neither can the human costs of vast bureaucracies reared in Washington by well-meaning liberals, vast airports erected on computerized systems in Dallas–Fort Worth, or huge, fatiguing, ponderous, and expensive museum buildings that cannot be changed thereafter, until they crumble finally to the ground in some distant time. The United States has built hundreds—perhaps thousands—of these abstract monoliths in the past thirty years, at a cost that might even stand up to the Vietnam war. Only one has seemed genuinely humane to me, genuinely a place where one might actually enjoy looking at art —or anything else—for an entire day. It is the Kimball Art Museum in Fort Worth, Texas, which was designed by the late Louis Kahn. He began that delightful structure, as you may know, from a basis in personal human experience. "I asked myself," he told me once, "why I was fatigued within fifteen minutes by every museum I ever entered."

So it is well worth your while and mine to stop and think about museums in personal and meaningful ways for a minute. It is also worthwhile to look at them from the standpoint of other experiences and ideologies—the less like ours the better. In 1941 a curator of Indian descent named Ananda K. Coomaraswamy (then working at the Boston Museum) went to the American Association of Museums and delivered a lecture that shocked everyone in attendance simply on the basis of its title: "Why Exhibit Works of Art?" He argued that American museums are misleading their

voracious public by exhibiting objects in aesthetic isolation from their cultures and their purposes. This is particularly so in the case of implements, furniture, and jewelry made in primitive or non-Western cultures, where the idea of art as an activity divorced from real life, without purpose, valuable only in itself, is not accepted:

Furnishing originally meant tables and chairs for use and not as interior decoration designed . . . to display our connoisseurship. We must not think of ornament as something added to an object which might have been ugly without it. . . . Primitive ornament had a magical . . . a metaphysical value, since it is generally by means of what we now call decoration that a thing is ritually transformed and made to function spiritually as well as physically. The use of solar symbols in harness . . . makes the steed a sun in a likeness . . . the egg and dart pattern was originally what it still is in India, a lotus petal moulding symbolic of a solid foundation. It is only when the symbolic values of ornament have been lost, that decoration becomes a sophistry, irresponsible to the content of the work.

It is precisely because our ideology is so different, Coomaraswamy argued, that the context needs to be added by the museum, or the meaning of the object, beyond its form, loses its power and becomes, in fact, emasculated. Thus does the museum act as a barrier between us and human reality—or the world—as it really exists. Which is precisely why so many people complain that art is boring, seen in a museum context: "Aesthetic experience," argues Coomaraswamy, "is of the skin you love to touch, or the fruit you love to taste. 'Disinterested aesthetic contemplation' is a contradiction in terms and a complete nonsense."

Coomaraswamy is not entirely right, of course. But he vividly raises certain basic questions that never seem to get into the dialogue about the future of American museums. He is mainly worried about the role of museums in abstracting (and therefore distorting) reality. In this sense, it is playing a role very much like that those computer printouts played for the Pentagon and the White House when they met to make decisions in Vietnam. Further-

more, the public appears to have a libido for abstraction. The radicals in the avant-garde who naïvely call for trustee power to the people, or public funds in place of private as the means of radicalizing the museum, are in for a considerable shock when the revolution comes. What the people always want when they come to power is what they have been taught to admire in the past—and that means, for museums, the bloodless parade of abstracted and sanctified objects. "The people" flock to the Metropolitan Museum in New York in staggering numbers, devouring precisely those exhibitions that anger not only the art left but the art academy—the purloined Greek krater, the bravura display of Impressionist masterpieces, the radiant new Lehman Wing, choked with medieval, Renaissance, and nineteenth-century icons. At the height of the bitter attacks by the art community on the elitist tendencies of the Museum of Modern Art in New York in the early 1970s, the people were besieging MOMA in record numbers to see the priceless and sanctified Gertrude Stein collection—an elitist tour de force. When last I looked, the museums had increased their total attendance from 50 million to 300 million in less than forty years.

So we cannot expect to convince the American museum to change its ways on the ground of populist appeals. The argument must proceed on very deep levels and must tie itself to an end beyond mere numbers. The appeal must be to a truth that transcends immediate success and is involved with the sanity of the entire society. I am not at all sanguine that it can be done, as I said before, but stranger things have happened: when John Henry Newman wrote *The Idea of a University* in 1852 he challenged a set of assumptions about education that seemed unshakable. Six years after the publication of his lectures he was forced to resign the rectorship of the new university in Ireland that had been created to illustrate his theories. But today Newman's core idea—that education (even religious education) should be broad in subject, specific in application, and secular in its focus—is widely

accepted and practiced in the West: we call it, now, "liberal education."

The set of mind against which I am speaking seems equally unshakable. Every chance it gets, the museum establishment waves its fist at me and reminds me of the truth. The American Assembly Conference of museum leaders passed early this year a series of resolutions that either specifically march off in an alien direction or crawl that way under cover of night. For example: "Art museums should not become political or social advocates except on matters directly affecting the interests of the arts or the aesthetic life of the community." Again: "Although the museum is educational by just existing, its primary educational function should be to increase visual literacy by teaching people to see. To accomplish this, it is desirable to separate intrusive educational devices from the original works of art exhibited and preferably to rely upon individual instruction of the viewer and viewer-object relationship."[1] Finally, there was a rather lame and negative endorsement of the presence of artists on boards of trustees that revealed, at the very least, an alarming lack of passionate commitment: "Artists should *not* be excluded," the resolution says (italics mine), "from policy-making or governing bodies of museums."[2] Once when I suggested in a spirited debate with Thomas Hoving that the highest goal of a museum might be something other than the costly acquisition of art icons, he shook his fist at me—some of you may have seen the published photograph—transferring my metaphor of the angry museum leadership into fleshly fact.

Behind the American Assembly is the weight of history—that is, history as it is officially interpreted. I would like to stir up some doubts about this history. Although we can trace the origins of the word "museum" back to the Greeks (it meant "realm of the muses" and is interpreted by Alma Wittlin to denote "a place where man's mind could attain a mood of aloofness about everyday affairs"[3]), the modern museum began in the atmosphere of the French Revolution, in 1793. This was the signal shot that con-

verted in the next hundred years most of the great palace collec-
tions, castles, and fiefdoms into public institutions, open to all. It
did not happen without a struggle—the Louvre changed hands
and purposes throughout the early nineteenth century, as right
and left succeeded each other to power. But the revolution of
1848 finally clinched it: then the Louvre was removed from the
Royal Civil List and turned into national (that is to say, public)
property. This was in fact the only way to preserve art from de-
struction; the revolutionaries cried, "We shall never get rid of
kings until we pull down the palaces"—and they did, even in the
Tuileries. But when they stormed the steps of the Louvre itself, on
a fateful night in 1848, Philippe Auguste Jeanron, a radical painter
of unquestionable proletarian credentials, met his colleagues at
the door and argued—convincingly—that art was the expression
of the people, not their discredited leaders. In the even more
hectic days of the Paris Commune in 1871, Gustave Courbet,
another spotless radical, prevented the destruction of antique
bronzes throughout Paris (though he consented and perhaps
joined in the destruction of the tower of Napoleon in Vendôme).
His assistant, Demay, said: "These little bronzes are the history of
humanity and we want to conserve the intelligence of the past and
the edification of the future. We are not barbarians."

I mention this to indicate not only that the supposedly inexora-
ble history of the modern museum is, in fact (like all history), the
product of chance and of individuals (what if Jeanron had not
persuaded the looters in 1848?), but that the idea of art has sur-
vived every conceivable kind of uprising—physical, social, and
intellectual. And it is the idea of art—not its physical form—that
obsesses me. Think of it. Through all the successive French upris-
ings, while country homes collapse and human heads are severed
with abandon, through the rowdy street demonstrations pro-
moted by Dada and Futurism (remember Marinetti proclaiming:
"Destroy museums and libraries!"), through the fury of the several
Russian revolutions (remember Malevich: "In the name of tomor-

row we shall burn Raphael"), and finally the wave of bloodletting events, street demonstrations, threats, cancellations of exhibitions, draping of paintings, and museum sit-ins during the late 1960s in New York, still there is remarkably little damage visited on either the museums or their collections. Not even the wildest radical has yet taken his hand to art—not the Irish revolutionary kidnappers of paintings, not Jon Hendricks, not even Jean Toche (who was almost jailed for demanding that we kidnap the persons of museum trustees, Douglas Dillon specifically). When Schafrazi sprayed paint on *Guernica* at the Museum of Modern Art, he sprayed it with paint that was easily and quickly removed, leaving no trace; that he knew it would not last is proved by the presence of a photographer, brought along to document the act.

Why? If we could answer this question we could chart a museum for the next century that would be true, rather than false, a catalyst rather than an entertainment. Let me begin to do this in a roundabout way, by describing the recent experiences of a society fully as large and as complicated as ours: the Soviet Union. Lenin and Trotsky never endorsed the extreme anti-art proclamations uttered by their own avant-garde—the very artists who (in contrast to their conservative colleagues) supported the Bolshevik revolution. This is a complex subject, not to be reduced to banal simplicities, but the net effect of the gradual alienation between Malevich, Lissitsky, Tatlin, Rodchenko, Vertov, Eisenstein, and countless other brilliant talents in art, architecture, theater, and film—and the leadership that supported them so stoutly in the early 1920s—was to raise an issue that is always with us: whether art (and the museum) is to provoke and lead or to pacify and glorify what is. The Russian decision—which ought to instruct us—was for the latter. The debates that took place in the Soviet Union during the 1920s (when the issue was still in doubt; upon the full accession of Stalin, debate ceased) are open and on the record. John Bowlt has catalogued them briefly in his essay "The Failed Utopia," where the conflict is seen largely as a struggle between an ob-

scurantist intellectual elite and the righteous populists who wanted to make art available—through an easily understood realist style in painting and narrative in film—to the masses.[4]

But what a bloodless and removed (not to say false) analysis this is, analogous to the claims now being made by government bureaucrats in the U.S. posing as populists—in behalf of controlling the product they fund! Let me tell you of an actual encounter between the Soviet populists and Mayakovsky, the main spokesman for Constructivism and now recognized (decades later, after his suicide, in 1930) as the central poet of the revolution:

SPEAKER: "Your poems can't be understood, Mayakovsky."
MAYAKOVSKY: "Who doesn't understand them?"
REPLY: "I don't, for example."
MAYAKOVSKY: "Very good. Poems must be understood, but also the reader must be understanding."
REPLY: "But you write so that one cannot understand."
MAYAKOVSKY: "You can't put the question like this: if I don't understand, then it is the writer who is the fool!"[5]

On another occasion Mayakovsky openly attacked the self-styled populists:

I ask you, is this culture? I have my own opinion. Take, for example, the classic picture, about which much has been written, the painting of Brodsky, "A Conference of the Communists," and see to what horror, to what banality, to what depths can sink an artist-communist. I will give my reasons for saying this. . . . Excuse me, comrades, but I cannot see any difference whatsoever between the drawings of the members of the State Council and the drawings of the workers of our Comintern. I cannot see any difference at all, despite the desire to have before one, permanently, or at least temporarily, deeply respected comrades. Further, I would point out, comrades, that in the attempt to limn for us the figure, face, all the aspects of the body of Vladimir Ilyich [Lenin] the work of the artist equals nil.

At the best these artists could lift art to the highest examples of Rubens, Rembrandt, etc., but that won't happen. Now these are over-all the most talentless, the most petty imitators, having no active revolutionary role in their whole life, in the whole cultural upsurge of our republic, and never will have. The same with the theaters.[6]

Of course, Mayakovsky and his colleagues lost the argument. Stalinism triumphed, in the name of a "popular," easily accessible art and museums for the masses. Until very recently, the visual arts have been the most disciplined and controlled activity in the U.S.S.R., saving only overt political dissent. Free exchange of information and expression has been gradually increased since 1945 in the sciences, in athletics, in industrial production, and finally, to some extent, in literature, drama, music, dance, and film. What has been the result? Everyone knows the answer, including the Russian government itself, I suspect: contemporary painting and sculpture in the Soviet Union is in a state of embarrassing exhaustion. Where once Russian art was in a position of world leadership, it cannot now even get itself shown at the Metropolitan in New York, always eager for anything shipped from Moscow.

There is a great deal to be learned from this lesson, I believe, and from others. One of them is that the function of the new museum—like the function of art itself—is not to pander to popularity. That is properly the function of commercial entertainment. It was not in the service of entertainment that the revolutionaries prevented the Louvre from destruction. Nor is it really why you have appropriated seven million dollars to create and extend a new kind of institution in your city. Whatever may be said now and then, the city of Long Beach instinctively expects its museum to provide more information, and on a higher level, than the six o'clock news or *The Tonight Show*. Certainly it is fair to say that what is communicated from this museum-forum ought to in some deep way advance us beyond where we are now, collectively, or where we have been—for we know that isn't good enough; every sign, ecological and economic, tells us that the formalist society is slowly devouring itself. That is why the populists eventually destroy culture whenever they begin to control it, and why documents like the present UNESCO survey of world culture, "proving" that most people around the globe don't understand advanced art and therefore dislike it, are so profoundly damaging.

The conclusion—that museums and artists ought to simplify their message for the public—is wrong, even on a populist level. As the avant-garde has multiplied, flourished, and advanced into stranger and stranger areas of activity, its audience has grown, not diminished. Whatever the public may say about disliking art that can't be easily understood it disproves with its feet, and its increasing interest.

Another product of the American Assembly Conference on Museums is an apparently radical work of sociology by Robert Coles, in which he proves by a series of interviews with young minority students (that is, blacks and Puerto Ricans) that they really don't understand what they see in their early visits to "white elitist" museums.[7] But what transparent (and reverse) racism lurks under this kind of writing, and its obvious conclusion—that museums should render their offerings simpler for the minority audience. Do white students understand or approve of what they see in museums, early or late? Understanding is not the issue—it is a precious and rare commodity, in any case. The museum cannot be inhibited by arguments like this from offering difficult or provocative exhibitions. Often the very student who tells the sociologist that he is alienated or confused by what he sees might look again, for precisely that reason. The populists mistake the mission of the museum for the mission that is proper to vaudeville, commercial television, or the community chamber of commerce.

This is also the reason why the architecture of the American museum so often clashes with what is shown there. The people who control architectural decisions in our communities are always searching for plans and designs that will impress and overwhelm the public: the Pasadena Museum and the Hirshhorn Museum are two recent and exorbitantly expensive examples to which I will return in a minute. In an age when disposable, flexible materials and construction methods abound, the decision is time and again to erect at great cost monoliths in the image of the past, of where we have been. The purpose of these monoliths is not to provoke

or to communicate, but to impress. And now I would like to quote
from *Architecture 2000* by Charles Jencks, a young British archi-
tect. In this book, Jencks admirably suceeds in doing for architec-
ture precisely what I am trying to do for museums—to show that
our significant decisions are based not on necessity or logic, but on
underlying, invisible patterns of thought and opinion. To wit:

When men . . . become the measure of all things, then truth becomes
relativized beyond control and men become victims of other men and
themselves. Without a court of appeal outside of man, that transcends
man, that is true or false regardless of what men hold, all thought and
action will be corrupted by power. All disputes . . . will tend to be resolved
by the strongest and it will lead to the "monstrous acts" . . . which are
continually perpetrated by dictatorships and pragmatists alike. . . . Almost
all of the classic religions were well aware of this problem and continually
acted as alternatives to temporal power and such utterly debased philoso-
phies as "might makes right," "all truth is relative." . . . The greatest
problem today is that with "the disappearance of God," or a regulative
idea of truth which transcends man, there is little check on temporal
power or relativism. All truth becomes a matter of opinion and is manipu-
lated by one group or another for its limited and provincial ends.[8]

Which brings me to the description of what the twenty-first-
century museum should be—not what it will be, if my premoni-
tions are correct. And I begin with a premise—with what Jencks
might call "a regulative idea"—on the assumption that to reason
from sound truths will always lead us to the right end (the reverse
of the process of thinking that guided us in Vietnam and the
positive of the process employed to write the American Constitu-
tion). The premise is this: the twenty-first-century museum must
communicate an attitude that will enable us to improve on what
and where we are now. What we are now—as I have been trying
to say—is an abstract, formalist society obsessed with how rather
than what, or why. Another way to put it is this: the museum is
content, not form. What counts is neither the building, the collec-
tion, the size of the staff, nor the budget, but what these separate
systems communicate, as one whole entity. All these areas I in fact

John Johansen, *The Mummer's Theater,* Oklahoma City, Oklahoma, 1970.

concede to others and to the specific needs of specific times and places—though I am obviously biased in favor of changeable, flexible structures that can be dismantled and moved at will, in the manner of John Johansen's Mummer's Theater in Oklahoma City.

The only specific form that I insist upon is virtually a non-form: television. It should be the core of all museum planning and thinking in the next century. André Malraux wrote an infamous tract called *The Museum Without Walls,* in which he argued that the presence of the art object was no longer required to communicate its essence, since it travels far more extensively through photographic reproduction. Malraux has lately been attacked for abstracting the experience of art. The truth is that he never understood the profound argument made by Walter Benjamin in "The Work of Art in the Age of Mechanical Reproduction" written in the nineteen-thirties, an essay on which Malraux, a fellow Marxist then, depended. Benjamin believed that reproduction vitiates the "aura" of a work of art—its specific location and its private ownership. He saw that as an irreversible process, to be used and improved upon by the artist—not to be served up (in the manner of Malraux's book) as a substitute for real experience.

Television, because it exists in time, does not of its own volition abstract reality, as does the photograph. What Coomaraswamy asked for in the display of artifacts from the past becomes infinitely possible through television. Nor is the viewer asked to fatigue and dehumanize himself by attendance in an oversized chapel, where his attention is difficult to focus and sustain. The museum can communicate through television on a private, mind-to-mind level. It can focus and deepen the experience of art, rather than promote the superficial "now I have seen it all in ten minutes" experience indoctrinated by the bravura Hoving method. Television restores context and content to the work of art—anybody's work of art.

Does what I am saying clash with your experience of television? With the mind-numbing effect of countless hours of prime-time

comedy and household drama? Remember that commercial television has forced this view of the medium on us, in its abstraction of ideas, news events, and time itself (television is dedicated to speed: cut, cut, cut, from Saigon to Chicago to joke to song). But a minute's thought reveals the idiocy inherent in this use of television: there is no mass audience for this medium, waiting in huge, assembled throngs for more circus acts. At any one moment there is only one mind—or two—or three—on the other side of the screen. It is an audience closer to the audience for the book or the poem than for the circus. It is, in fact, the museum audience.

It ought also to be clear from what I have been saying that the economic structure of a museum fit for the next century has to be different from the present structure. As a matter of fact, it will be —the only confident prediction I make to you now. The days when a few wealthy citizens could fund and manage an American museum are gone. The museum is now inevitably a chameleon creature, suspended between private and public sources of support. The second point is this: the bulk of our museum budgets have to begin to shift toward content rather than form—toward what the museum has to say, through its exhibitions, its catalogues, its resident artists, and its two-way dialogue with the public. Peter Plagens, in his article criticizing the booster origins of the Long Beach Museum, recommends that four to six million dollars be spent on the following: "Five or six storefront museums, each with a specialty, a neighborhood, each with a sense of 'real' space, and the tacky verisimilitude of a serious commercial gallery."[9]

If that sounds risky, consider the alternative at the other extreme, the alternative most often followed, most recently by the Pasadena and Hirshhorn museums. In both cases, the planners held stubbornly to the old notion of the museum as fortress for precious objects, devoting vast sums to buildings that have roused virtually international indignation: the Pasadena Museum has been described as "late Neiman-Marcus," the Hirshhorn as "a Cultural Bunker." Neither museum had proper funds left over

either to mount a strong exhibition program or to diversify its collection. We all know—through John Coplans—what happened to the Pasadena Museum, which in fact is dead.[10] I predict something of the same fate for the beleaguered Hirshhorn, which has ahead many years of scrounging for acquisition funds from a reluctant and besieged Congress, while the Hirshhorn collection itself is shown and reshown, to increasingly critical analysis and dissection—a process that has already begun. It could in time ruin any chance the museum had to act as a center for contemporary art in the moribund capital. To go this route is decidedly more risky (in its pragmatic consequences) than the worst results of following Plagens's proposals, or mine.

The time—in brief—is ripe for a new concept, of the museum not as a place, not as an object, but as a moving, three-dimensional, human solvent, a disseminator of regulative truths rather than abstracted objects. What are these truths? Now you will think that I am about to lapse into vague mysticism, as did Charles Jencks when it came to defining an alternative to lost religious beliefs. But I don't think any of us really doubts the substance of these truths, the new alternative to the idea as power. Nor is it in fact very new. Its core thought is simply this: that no action ends with itself. Everything I do, you do, others do, affects the whole ecology of mind and matter. Therefore, arbitrary personal conduct, undertaken without a larger frame of reference, is wrong. This truth—or content—is neither difficult to implement nor beyond the ability of a museum to communicate. There is no law written into the fabric of museum history that dictates against the museum as content. It is only an opinion susceptible to change, and an opinion difficult to defend. The pretense that neither museums nor art have anything to do with specific issues or times promotes, says Daniel Buren, the false notion of "An immortal art, an eternal work, and an apolitical man." Formalism is thus—as I have always argued—a political ideology rather than an aesthetic one, encouraging us to neglect rather than to improve upon the status quo.

Toward the end of improvement, all the tenses of art can be joined, and employed, in the new museum. When Courbet framed a manifesto asking that artists take over the art world, he stated three goals, all of which can be applied to the program of the twenty-first century museum:

1. Preservation—of the past.
2. Revelation—ordering all the elements of the present.
3. Regeneration—of the future, through education and dissemination.

In other words, he saw art—and the museum—as a leader of the people, not their servant. Furthermore, he saw—in his insistence on caring for present and future as well as past—that the museum, like every citizen, must be responsible for the larger consequences of its actions. Courbet thus directly confronted the false notion that either art or the museum is above everyday life. What I have tried to do is set you to facing that truth, in order to turn it into a positive program. If you can do this, you will be ready for the next century twenty years before it arrives.

NOTES

1. A welcome contrast to this statement is the address of Rep. John Brademas (D-Ind.) to the AAM itself on June 1, 1976, in Washington, in which he cites education as a *primary* role of the museum.
2. Cf. Milton Esterow, "The Future of American Museums," *Art News,* January 1975, pp. 34–37.
3. Ms. Wittlin's interpretation—in her book, *Museums in Search of a Usable Future,* (Cambridge, Mass., 1970)—is also a matter of opinion rather than fact. The contemplative dialogues of Socrates are filled with pressing practical and political topics; furthermore, the Greeks did distinguish in their language and literature between "fine" and "applied" arts, as we do. Thus I doubt whether it is correct to assume that the ideal Greek "realm of the muses" is removed entirely from everyday life.
4. John Bowlt, "The Failed Utopia: Russian Art 1917–1932," included in

Museums in Crisis, ed. Brian O'Doherty (New York, 1972), pp. 43–63.

5. *Mayakovsky: Poems,* ed., trans., and introd. by Herbert Marshall (New York, 1965), p. 25.

6. Ibid., pp. 36–37.

7. Robert Coles, "The Art Museum and the Pressures of Society," *Art News,* January 1975, pp. 24–33.

8. Charles Jencks, *Architecture 2000* (New York, 1971), pp. 119–120.

9. "L.B.M.A., M.O.C.A., P.M.M.A., L.A.C.M.A.," *Artforum,* October 1973, pp. 82–84.

10. "Pasadena's Collapse and the Simon Takeover," *Artforum,* February 1975, pp. 28–45.

Utopia: Thinking (with Ad Reinhardt) About the End of Art

> The honest position is hard to work out. But I won't play the idiot, the kind of painter who pretends he doesn't know what is being done to him (the idiot role requires a great deal of shrewdness, incidentally). The worst thing you can say about me is that I've been a professor—and that's pretty bad. Art is neither good or bad for people. I think at the same time that anybody who looks to it for salvation will be disappointed. Art is not a way of living it up —or down. It's really not a career or trade or profession. Fine art is none of these things.
>
> —Ad Reinhardt, conversation with the author, 1966

SURELY THE TITLE of this lecture has surprised some of you. In a sense that I will shortly explain, it surprises me as well. Upon hearing it, a supercilious friend told me he wasn't daunted by the subject—which he confidently expected—but by its first place of delivery, in a city noted for its conservatism in the visual arts. But the truth is, I think Washington is perfect for the ideas I have in mind. There is no use in my talking to the convinced in SoHo, in Nova Scotia, or at the Museum of Conceptual Art in San Francisco. Here I must face an entirely different set of perceptions. The

First delivered as a lecture at the Hirshhorn Museum, Washington, D.C., December 1975.

prevailing critical and esthetic tone in Washington (with a few significant exceptions; perhaps in time this museum will be one) is purist and formalist, two terms I hope you will let me define better in the course of the discussion. It is not by accident that the Washington Color School was set in motion by Clement Greenberg, or that the new curator of modern art at the prestigious National Gallery shares that persuasion, or that the chief curator at the Hirshhorn recently announced that he would increase the number of Morris Louises on view and decrease the space devoted to Pop art in the permanent installation.

In this context it appears incongruous to speak or write about Utopia and art, rather than the iconography of chevrons, stripes, and poured color. This subject implies that I mean to discuss art in a context broader than itself, a context both social and intellectual. But I have been trying in recent years to reach out to subjects lately ignored by artists, historians, and critics in this country, if not abroad. I mean no animosity to formalism or to Greenberg by so reaching. I was born, trained, and educated in his ideas (and in this city), so I am not trying to reach beyond him as a person or as a thinker (I rather admire his thought) but simply beyond what I have been taught, and beyond the normal dialogue about art that takes place in American education, publication, and conversation.

Utopia is in fact a subject I would have preferred to avoid, simply because its connotations are so distasteful. To be called a "Utopian" in 1975 is to be called nothing less than a romantic fool, a hopeless optimist. I never considered myself to be either until publication of my book *Art and the Future*, which, by the very nature of its subject, called for a discussion of Utopian art movements like Futurism and Constructivism. Not long after, I found myself linked in reviews of the book to this very specific and dated brand of Utopianism, as if it were a personal commitment. My involvement with the use of videotape as a means for making art further blackened my name, since the movement itself was saturated (on its fringes) with a McLuhanized Global Village rhetoric,

which I never shared. I thought myself an innocent, rational man surrounded by idiots until even a colleague I very much respected called me a "Utopian" in the midst of a public seminar, in 1974. I recall now what H. L. Mencken once said: No criticism, however absurd, is entirely wrong. And so I have decided—in effect—to investigate myself, and the subject of Utopia.

Having done so—and being about to report the results to you— I am first of all still convinced that I am not a Utopian in the conventional sense of the term. But more important, I found that the issue of Utopia cuts right to the heart of the rationale of contemporary art, and indeed all art. It is an issue of particular heat at the moment, when we are being told time and again that the expansionist tendencies of American art in the 1960s—which of course implied an engagement in extra-art materials and themes —are finished, laid low by recession, political retrenchment, and the return not only to painting but to a private ethic by artists, who are, says Robert Morris in the October 1975 *Artforum*, "deeply skeptical of experiences beyond the reach of the body . . . equally skeptical of participating in any public art enterprise."[1] Thus we are discussing a subject that has misled us both: its implications stretch far beyond my own personal concerns and they impinge directly upon you, as an audience engaged in the continuing development of contemporary art.

Let us begin by defining this subject. "Utopia," says the dictionary, "is any condition, place, or situation of political perfection . . . any idealistic goal or concept for reform." But it was Thomas More who introduced the term into the language, in 1516, and he lifted it from the Greek, in which it meant "Nowhere." Right away, then, we can sense a distortion of the original purpose and its acceptance in common parlance, a loss not only of irony (More knew perfectly well that his ideal commonwealth was impossible, in a literal sense; he even named his spokesman Hythloday, which in Greek means "speaker of nonsense") but of worldliness. To a certain sector of the public, any proposal for reform or change, in

politics or in art, is instantly dismissed as naïve, in complete dis-
regard for the bottom-line purpose of the proposal, or the real
nature of the proposer. In recent art, this charge has been leveled
in various ways at Joseph Beuys and Hans Haacke, whose worldli-
ness—like More's—is in fact beyond question. Beuys very nearly
changed the nature of art education in Germany through his con-
tinuing political *Aktions* (or performances, we might say); he fell
short, but he is about to set up yet another school—a Free Interna-
tional University in Dublin. No one who has tried to teach, to
shape even a moderately new curriculum at any school (liberal or
professional), or to introduce any art-related issue into the public
consciousness (Beuys's struggle against the Düsseldorf Art Acad-
emy was headline news for several years) can underestimate the
sheer tenacity—not to say cynicism—that is required to meet
these ends. The same is true of Haacke, who not only survived an
epic battle with a major museum and the inevitable resistance that
his continued probing into the hidden systems of economic and
bureaucratic power engenders: he recently won tenure on the
faculty at Cooper Union. Again I say that no one who has ever
attempted any deeds remotely like these (including the winning
of tenure in a recession) can underestimate their difficulty.

Neither Beuys nor Haacke is a Utopian in the popular sense,
then—happy, naïve, otherworldly. Nor are they in fact to be fitted
into left-wing or right-wing groups, on any issue. Beuys is as op-
posed to the statist dictatorships of Eastern Europe as he is to the
capitalists in his own country; Haacke lately addressed a group of
students at Antioch and amazed them by warning like any good
rightist against the perils of unions (artists' unions in particular). It
is not, therefore, correct to tar every new idea, every new move-
ment, every new reform with the brush of uncritical, enthusiastic
reformism or pseudo-Marxism. What this tactic misses, in addition
to the specific content of the proposition advanced, is another,
diametrically opposed motive. For want of a better term, I will call
it desperation. Faced with what appears to be an implacably hos-

tile climate—political, esthetic, or philosophic—the mind is driven to fabricate an extreme alternative, in the service of sanity. There is, in other words, a necessity for Utopia. Those who act in its service often act out despair rather than hope. Once I was asked whether I believed I could change commercial television through *The Austrian Tapes,* the work in which I ask the viewer to touch my hands through his television screen. I replied that I didn't know: I was too busy trying to get the work *on* commercial television. That art is a natural vehicle for this driven impulse—perhaps the best vehicle of all—is the main burden of my case today.

I am not talking about organizing art communes in the mountains or religious communities in the woods. Shaker Village and Drop City, Colorado (the site of a famous artists' commune) share an affection for isolation and an indifference to the outside world. No, the activity I am trying to define is concerned with more than personal salvation. It begins—as all art begins—in the self, in the private act, but it is conditioned by and appears in a public world. So, of course, does the commune, but against its will. Later I will argue that art used to accept this function willingly, before certain modernist ideologies took hold. When Al Leslie deserted abstraction for a realist mode grounded in the structures of the past, he changed radically the way he talked about art, and its purpose. In a recent catalogue statement he said this:

I wanted to put back into art all the painting that the Modernists took out by restoring the practice of pre-20th Century painting. . . . I made pictures that demanded the recognition of individual and specific people . . . straightforward, unequivocal and with a persuasive moral, even didactic, tone. I wanted an art like the art of David, Caravaggio, and Rubens, meant to influence the conduct of people.

Now, I don't notice my critical colleagues heaping abuse upon Leslie for this undeniably soft-headed, world-saving statement. The "Utopian" adjective is selectively applied to artists employing mediums other than pigment, clay, or bronze. I have lately

heard Walter Gropius, founder of the Bauhaus, denounced severely for taking precisely the same stand now occupied by Leslie, with regard to architecture and interior design—in brief, that it can and should influence conduct. The mood of the time—to borrow a phrase from literary criticism in the fifties—is "wary, tight-lipped, tough-minded." It is unwilling to cede any role for art beyond itself, which is of course to abdicate that role. Malevich's statement in 1922—"Art must become the content of life"—seems absurd in 1975. This black mood is shared by the American body politic at the present moment, yet another proof that the supposed line between art and life is as thin as ever. Robert Morris says, in the same article that I quoted before, that "the art of the 60's was . . . open and had an impulse for public scale. . . . The art of that decade was one of dialogue, the power of the individual artist to contribute to public, relatively stable formats which critical strategies did not crumble until late in the decade. Mid-way into the 70's one energetic part of the art horizon has a completely different profile. Here the private replaces the public impulse."[2]

I hasten to say that I share Morris's feeling; I have been defending the privacy of art for many years; so has Max Kozloff. The difference between all of us has to do not with premise but with conclusions—that is, our respective strategies for action. More of this later.

Clement Greenberg and Harold Rosenberg deserted the notion that art has a public function long before Morris, or any of us. I have already discussed many times the switch in Greenberg— from Marxist to formalist polemics. Here is Rosenberg, who also spoke in Marxist rhetoric once, in his famous essay on De Kooning more than a decade ago. After praising De Kooning for discarding his proletarian sympathies and images of the thirties, and flatly announcing that "art in the service of politics declined after the war," he states his creed:

It is still the rare artist who trusts his work entirely to intuitions that arise in the course of creating it. Foremost among such adventurers in chaos is Willem De Kooning. . . . To detach painting from fixed social, esthetic, or metaphysical beliefs is basically to redefine the profession of painting. The function of art is no longer to satisfy wants, including intellectual wants, but to serve as a stimulus to further creation. The Sistine Chapel is valuable not for the feelings it aroused in the past but for the creative acts it will instigate in the future. Art comes into being through a chain of inspiration.[3]

It is precisely against that position that much of the "public art" of the sixties—to borrow Morris's phrase—reacted. But the pendulum has swung again, and we are all receptive to Rosenberg's position now, in varying ways. Barbara Rose, once a spokesman for the sixties, has lately published a book on Ad Reinhardt, who is for me the critical figure in postwar American art, in which she defends and defines him basically on the following, decidedly black ground: "His importance as a precursor of . . . reductionist styles . . . is nowhere near as relevant today as his philosophy of art. . . . At this difficult moment, Reinhardt appears a prophet of the realization that high art can only endure as spiritual art even if this requires a return to medieval monasticism."[5] Not even Rose's black mood can match that of the French critic and avant-garde spokesman Alain Jouffroy, however, who said in 1971 that "The future of all societies has never appeared so gloomy."[5] Worse, the attempt by Duchamp and by Dada to destroy the canon of high, fine art must now be declared, he said, a definitive failure:

In all eyes in the so-called socialist world as in the capitalist world, the existence of art continues to appear as indestructible, as unshakeable as that of the Government, the Army, and the Police. Art is an integral part of all repressive institutions of the ideologies of all dominant classes in all social systems.[6]

Finally—and on a much different level—the Mexican poet and critic Octavio Paz, in league with the Club of Rome report[7] and the broadly based movement among sociologists and scientists to

slow if not stop mindless "progress," has declared the end of the modern age—the end, that is, of the time when we could cheerfully demolish past myths in the blind belief that new values would evolve to take their place. There are no new values, Paz says; there are only the constructions of technology, which "don't represent anything and, strictly speaking, they say nothing." And Professor Gunther Stent, a molecular biologist of great distinction, has lately written a book whose title admirably sums it all up: *The Coming of the Golden Age: A View of the End of Progress.*

Again I say—just to keep the record straight—that I am fully in accord with the premise presented in all these remarks, and my mood right now is as foul and as black as anyone's. I would gladly follow Ad Reinhardt to the ideal monastery described by Barbara Rose, if I could find it. E. H. Gombrich has lately reminded us that these preferences are not only conditioned by larger forces, but rooted in historic attitudes toward the purpose and meaning of art. The very word "avant-garde" emerged—as he tells us in his Cooper Union lecture of 1971—in a century when the social and political implications of esthetic action were clear, immediate, and direct, when the critical dialogue was not dominated by a Greenberg or a Rosenberg claiming that a painting (unlike all other known objects) has no root in its own time, simply because it is a painting.[8]

The first man to use "avant-garde" in its present context was Gabriel-Désiré Laverdan, disciple of the Utopian socialist Fourier, who claimed in an 1845 pamphlet that the mission of art is to advance mankind, and that the way to determine the worth of any artist is first to know "where mankind is heading, and what is the destiny of the species."[9] The art of Courbet—now taught largely as a technical advance in form and perception—was called then "an engine of revolution." Proudhon—the very socialist later reviled by Marx for his "Utopian" ideals—described Courbet as the perfect model for leftist artists. The right rejected him because his paintings were too immediate, too fashionable, too much an-

chored in specific subject matter: art, said one of Courbet's critics, presaging Rosenberg, is timeless, rooted in "classical beauty." This was a time, says Gombrich, when "you could guess a person's political and social loyalties by the type of painting he favored—though you could guess wrong." What is more, this has always been more or less so. There has always been a faction that thought of art as an active force in the society, a tool of discovery, and a faction that considered it to be essentially passive, a tool of restatement. Rousseau—occupying the first ground—attacked the school of Watteau for taking the second in 1750: "If there really happened to exist a genius today who possessed the strength of mind to refuse a compromise with the spirit of the age and to demean himself with puerile trifles, woe to him."[10] Gombrich has even ordered for us the adjectives normally preferred by each side: "new," "revolutionary," "exciting," are the passwords of the avant-garde; "immutable," "noble," "ideal," comforts the other side.

I go into all this to remind you of two conflicting points about the apparently private art of the 1970s. First, the position we are now occupying (some of us for the first time) is an old one, seemingly rooted in the nature of the human mind, as is the reverse—the public, probing position. Second, a great deal of the rhetoric I just quoted to you is indeed mood rhetoric, as likely to pass, as likely to be fallible as the war whoops of the sixties. Though we have all been stunned by Vietnam, Watergate, and default, this is a country notorious for rapid political shifts. At present, we seem to have decided that the misdeeds of the past decade can be corrected by paring down and cutting back everywhere—most particularly in education, space, science, and social services (if not in the Pentagon), by returning to old ideas rather than maintaining our innovative edge. The art establishment is marching to a similar step, in its own way. We are filling up our contemporary museums with a combination that grows monotonous from state to state, with the inevitable flank of Louis, Noland, De Kooning,

and Pollock staring solemnly at each other, usually across a floor space bisected by Caro, with perhaps one David Smith spread out (unpainted) on the lawn outside. And of course we commission large Calders for the President. Now, I know it will shock you to hear that we are rapidly beginning to look as silly to the rest of the world as the École de Paris looked in the 1950s, as stultified and rigid as Joshua Reynolds's discourses to the Royal Academy, but we are. Serious critics and collectors who are interested in another side of American art *do* exist, mostly in Europe; they are little known here, if not ignored.

What we are presently missing (I trust temporarily) is a proper understanding, to say nothing of respect, for the second wing of art, the "other tradition," as the late Gene Swenson called it in 1966, in a little-read catalogue essay commissioned by the ICA in Philadelphia. Don't ask me to define it just yet, except to say that Swenson's essay devotes itself largely to Dada and Surrealism. All I will say now is that of course this second wing exists, it has always existed (as Gombrich himself concedes), and it does not prefer to dwell in monasteries, tempting though they are. The "other tradition" prefers, if you will, to live in the street. It is dirty out there, on the sidewalks, and not susceptible to clean, tidy arrangement. The art that is based on what I believe to be essentially non-formal problems can rarely confine itself to chevrons and stripes in a row. Even in those cases when it does present itself to us in clear, defined forms—as opposed to junk assemblage, political dialogues, or run-on telecasting—the unified composition disintegrates in our mind, because the implications of the work shatter the form: I believe this to be the case in the work of Beuys and Haacke, in certain Russian Constructivists (such as Tatlin, Rodchenko, and Mayakovsky), in the entire genre of performance art that has flourished in the past five years (particularly in New York, California, and Europe), and even in Ad Reinhardt's black paintings, though they are conventionally thought of as formalist.

Why? Because there is more to be thought through, organized,

and structured on the street than in the monastery. This is true even when the intention is to destroy or to negate form, as in the case of the early anti-formalist work of sculptors like Richard Serra and Carl Andre, or the grand act of "de-architecture" constructed by SITE (a group of young American architects) in Houston in 1975: I refer to the building whose façade appears to be decaying and crumbling, with hundreds of bricks sprawled down its face. Of course I grant that the art of chevrons and stripes—or of Watteau's forest frolics—can often project intellectually beyond itself, but normally the preoccupation is with its own physical ingredients. Some of you will be able to detect quite vividly the difference I can only discuss abstractly here when you see the large Rauschenberg exhibition at the National Collection of Fine Arts in the fall of 1976: there is a clear (at least to me) shift in his work from the early indecorous, sprawling collages and assemblages, when the artist felt (and regularly confessed) an affinity with the life of the street and of the nation (I refer here to his political involvement in the sixties with EAT), to the later work in printmaking, which is technically exquisitely refined but fixed in the nature of the materials themselves, even down to the composition of the paper, which serves—in the *Jammers* and *Hoarfrost* series—as both form and content.

Beuys and Haacke, in my mind, are on the fringe of this "other tradition," which is primarily the tradition Morse Peckham has in mind when he announces (with some glee) that in the past five years art has finally deserted its historic role as the organizer of consciousness. "Yet," he says, "the general tendency of this progressive reduction of redemption [that is to say, clarification and explanation of new and ideal value systems] has scarcely penetrated at all, though with the emergency of concept art, and funk art, and earth art, and packaging art it should have."[11] But here again we find the familiar assumption that art must either exhort us to idealism or stand convicted of disinterest in the world—the reverse of the coin that finds Utopianism in movements like radi-

cal Constructivism and any body of work charged with social content. Unlike its critics, art oscillates with ease between these two simplistic extremes; art can also employ them both at once: it can utilize otherworldly means directly to deal with the world. Like language, art can state, use, and resolve paradoxes.

Let me pursue this analogy with language a step further. Noam Chomsky has been persuasively reminding us in recent years that language is incurably dualistic in all its functions. Though language has laws (of grammar), it is also innovative, able to construct new meanings out of an old syntax or by revising its vocabulary. Language is both a product and a producer of the mind. It is synchronic and diachronic at once, fulfilling a universal and timeless function, yet always changing. Finally, language can deal with the practical and the abstract, with denotative and connotative meaning, and of course with two opposing or contradicting statements within one sentence. I will come back to this analogy again, but suffice it to say that both art and language—unlike practical action (with which they are too often confused, as by Peckham, above)—can probe into the world at the same moment that they remain uniquely themselves, apparently locked into their own structures. They are the purest and freest extensions of the mind.

Think back now to both Dada and Surrealism, the two movements in which both Swenson and I anchor the grand and overlooked tradition under discussion. Here, too, we have the appearance of otherworldliness and rejection yoked to a content that contradicts it. Even William Rubin—who wrote the classic account of the formal innovations in Dada and Surrealism—would concede that both movements were primarily motivated by extra-art ambitions.[12] Dada proclaimed over and over (as did Futurism and Constructivism) that it meant to destroy the existing order of thought and feeling, which caused the First World War. In Berlin Dada was explicitly political. One of its key members, John Heartfield, the founder of photo-collage, joined the Communist Party in 1918; he Anglicized his name (from Herzfelde) to protest German

nationalism; by 1924 he was at the head of the *Group Rouge*, dedicated to "class warfare" and anti-fascism. As some of you may not know, Heartfield chose after the war to live in East Germany, where he carried photo-collage to a striking extreme (a body of work unseen here, though it was displayed at the Musée d'Art Moderne in Paris in 1974). He maintained to the end that he used anti-form in behalf of the class struggle, unlike "bourgeois esthetics," by which he must have meant his less politicized Dada colleagues.

He could not have meant Breton, the main spokesman for Surrealism, who openly proclaimed that his movement intended to use the psychic material of the dream in the service of social change—by reconciling "collective myth" with the larger movement "to change fundamentally the bourgeois form of property." His manifestoes and poems—and those of his colleagues—are filled with similar claims. Breton saw the poetry of the dream as a direct communication with subconscious mental structures, contrary to the ordinary vision of things.

In radical Constructivism this covert world-saving becomes overt. But I would argue that the Utopian pronouncements by artists such as Tatlin, Rodchenko, Lissitsky, Malevich, and their friends were prompted by a moment in human history unlike any other that I can think of, or know about. It was a moment—a brief moment, like a grain of color on a white beach—when the avant-garde of power and of art were one. When traditional critics deride the Russians for their unbridled optimism, they do so out of inexcusable ignorance, and a cruel disregard for the price these artists finally paid (a price that was not inevitable). Furthermore —and more to the point—this is not evidence, strictly speaking, of Utopianism: what appears to us to be the postulation of imaginary absolutes seemed to them real. Imagine if you can a poet like Mayakovsky entering a radio studio for the first time, addressing his poems to a microphone for the first time, and informing that poetry with a content that barely two years before would have

landed him in prison, if not on his back. Seen in this light—and understood in a context in which Russia had telephones, electric power, trains, and full freedom of expression for the first time— the euphoria of Mayakovsky, the epic sweep of Eisenstein's films, and the architectural prophecies of Lissitsky seem not the expression of naïveté but of a poignant, aborted realism, roughly parallel to John Kennedy's strident promise (in 1960) of a moon landing within ten years. We might have failed in that quest, of course. The Russian vanguard might have succeeded—but for the fall of the dice after Lenin's death, which benefited Stalin.

Since the end of the second great war, artists in both Europe and America have continued to use the forms and techniques of the Dada-Constructivist-Surrealist heritage, minus the explicit political baggage—that is, until very recently. But what we sense in the most explicit of these artists, like Haacke, Beuys, Daniel Buren, and a few others, is not rosy optimism about the coming world order, but the reverse—a rage against the present order (Beuys is not asking for perfection; he is simply asking for a referendum to change the German constitution). Let me go on to mention some more names and movements that seem to me to primarily engage themselves in art beyond form: Yves Klein, Piero Manzoni, John Cage, Rauschenberg (of course), Jasper Johns, Morris, Richard Serra, Dennis Oppenheim, Vito Acconci, the Happening and virtually all the performance-theater work that followed it, virtually all of video, conceptual, and narrative art, and of course the Europeans I have already mentioned, who were gathered together in an exhibition at the ICA in London that would be unimaginable here now: "Art into Society," organized by Christos Joachimedes, Caroline Tisdale, and others. It included the work of seven artists—all Europeans with the exception of Haacke (who was born in Germany)—who have engaged their art directly in social issues.

I do not believe the Americans on my list shy off direct involvement because life is perfect here or because they are timid souls

Peter Hutchinson. "Friday," from *The Anarchist's Story,* 1975.
Photograph and text. Courtesy John Gibson Gallery, New York.

by nature. It is because of formalism's powerful hold on the rating system that still guides American art decisions. The basic requirement of this ideology is that no meaning of any kind can be allowed to pollute visual integrity. From our side this seems quite a natural and an innocent truth; from the European side it borders upon insanity, if not blindness (in comparing the collages of Vostell with the collages of Rauschenberg, one of these artists said: "For Rauschenberg Kennedy is just a smear of color. For Vostell, Kennedy is a politician, he stands in a political environ, and this has a completely different significance"). But I still maintain that the Americans I have named are a part of the tradition that engages politics. Morris might refuse to admit the historic implications of new materials, but he uses them. Kaprow has sheared the Dada theater of its anti-bourgeois content, but he employs it (the Happening is King Lear minus the last act). Vito Acconci may not claim to change or even care about the public (though he comes close), but he does. Conceptual art may have tried at first to use words divorced from denotative content but in the early issues of *The Fox* in 1975 and 1976 it assailed the institutions and pretensions of culture (a proto-Dada act). The new genre that has come to be known as "story art" may claim to be free of sobriety and intensity, but time and again it falls upon themes that have a peculiar weight. In *The Anarchist's Story*, a seven-part serial work combining photographs and texts, Peter Hutchinson tells us this, for example, while he describes the experiences of a marooned sailor:

Daniel De Foe's "Robinson Crusoe," like "Moby Dick," has very different implications to the present day. Reading "Moby Dick" all I can think about is how whales are being exterminated. "Robinson Crusoe" seems to say something about socialization. Dealing with solitude and people different from oneself is supposed to be a trauma. Today we all dream of being isolated on a desert island. The sight of a footprint in the sand would send us running in the opposite direction. In today's world there are no longer any spiritual desert islands.[13]

Let us use Hutchinson's text as an excuse to return to where we began—to the classic idea of Utopia, which I would like to define a bit more sharply. Up to now, I have intentionally left it vague, not only because I basically mean to discuss the colloquial usage of "Utopia" rather than any academic denotations. My basic purpose here is in fact the reverse of simplification and clarification. I am trying to demonstrate the inherent contradiction and complexity of subjects which we rarely think deeply about, as well as touch the mystery that surrounds some of them—particularly this idea: the idea that a man can rationally plan for an ideal community. The great academic authority on this issue, and the author of its central text, is Karl Mannheim. Here is what he tells us about the psychic implications of Utopian planning, in *Ideology and Utopia* (1936):

It is possible . . . that in the future, in a world in which there is never anything new, in which all is finished and each moment a repetition of the past, there can exist a condition in which thought will be utterly devoid of all ideological and utopian elements. But the complete elimination of reality-transcending elements from our world would lead us to a "matter-of-factness" which utimately would mean the decay of the human will. . . . The disappearance of utopia brings about a static state of affairs in which man himself becomes no more than a thing. We would then be faced with the greatest paradox imaginable, namely, that man, who has achieved the highest degree of rational mastery of existence, when history is ceasing to be blind fate, and is becoming more and more man's creation, with the relinquishment of utopias, man would lose his will to shape history and therewith his ability to understand it.[14]

If you will permit me a brief and bald paraphrase: When men renounce even the dream of perfection, they renounce themselves; they give up the pursuit of an ideal that is valuable basically because the pursuit orders their day-to-day existence. Without Utopia, we are left in the hands of chance, whim, nature, and pure power. If we are to take Mannheim's analysis a step further, it yields even more surprising results. The common or derogatory

view of the Utopian is that he is rigid and impractical. But the finer view points in a different direction. Once man gives up the possibility of change, his outlook becomes fatalistic and deterministic —one might almost say totalitarian. The Utopian spirit in art and language is open-ended and malleable; it is willing to consider alternatives (literature) and construct models for them (art). In this sense, formalist theory, which refuses to entertain any relationship between art and the world, as well as formalist linguistics, which ignores the function of meaning in language, are both closed systems.

At first glance, it would seem that the closed-system view is currently in ascendance. In literature, we create and respond to a thriving new genre: the anti-Utopia. It includes not only *1984* and Huxley's books, but countless science fiction tracts, movies, and the grotesque, distorted view of modern and post-modern life that fills the literature of the absurd, in Genêt, Artaud, Beckett, Ionesco, and in the more recent novels of John Barth, Thomas Pynchon, and Terry Southern. But the very power and consistency of this phenomenon ought to tell us the reverse of what is normally concluded about it. Men rarely rage at the demise of ideals that they do not cherish. It is much more likely that they rage because they have lost sight of something they need—and disagree with the means and plans lately advanced to achieve it. If I had the time, I think that I could chart the model for the new city out of the anti-Utopia: Beuys may have done it already. But that is another work.

For now, I remind you of Dada's reverse coin—its positive, world-saving, perfecting energy. The very least we can conclude about the entire "other tradition" is that it is obsessed with the social and physical specifics of the world around it, and anxious to deal with them—sometimes explicitly, as in Beuys and Haacke, sometimes implicitly, as in Rauschenberg's early collages and Kaprow's Happenings. It is only in the extremities of formalist art and criticism that we find—I think for the first time in history—the

notion that the artist has no business with the world, or any of its temporal, empirical concerns.

In one specific, limited sense, I understand this attitude. Art has no business dealing with *anything*. Art has no set task. It is the ultimate expression of what Gide called "the gratuitous act." For that reason, I place it not only above science but above philosophy. Unlike inductive reasoning, or even language—with which it shares the vital characteristics already noted—the act of artmaking has no functional role to play in the world, about which it can do nothing. I repeat: nothing.

But I still say that art is an inevitable vehicle for the Utopian instinct, which I take to be as natural to man as eating or sleeping, in agreement with Mannheim. In fact, the gratuitous nature of the act, as well as its physical-visual form (I call it art*making* for a pointed reason), suit it precisely to the expression of extremes in social thought and of paradoxes in feeling. Ad Reinhardt more than any other single American artist comprises within his thought and work the message I am trying to deliver to you. As Barbara Rose preaches her otherworldly post-formalist interpretation of Reinhardt, her own text is contradicting her sermon. Everywhere in Reinhardt's writings there is evidence of his very deep and very specific involvement with the political and moral issues of his own time. On these issues he takes time and again the most extreme idealist position. He tells us that the "next revolution" will see the end of personal art dealing and "the emancipation of the academy of art from its market-place fantasies and its emergence as a center of consciousness and conscience." He tells the artist to speak up in his own behalf (in advance of Douglas Huebler and Conceptual art), and not accept the "anti-intellectual" role foisted on him by society. He writes during the last war that "aesthetic values are inherent in all activities of life" and that artists ought "to help people obtain and create [art]." He was also, of course, a political cartoonist for the socialist newspaper *PM* and an inveterate picketer and protester. He said and did other things as well, diametri-

cally opposed to these activities. He said: "Purity is greatness." He said: "Art's Virtue is its own Reward." Most of all, he said, he wanted to make a painting without color, that resisted conflicting interpretation, and resisted photography: "the most 'modern' modern art, the most 'abstract' abstract painting of our time, art-as-art-only-as-art."[15]

Yet we know that none of this is completely so. The black paintings are not completely black. They are not completely abstract. Nor do they resist interpretation. Reinhardt was not pure, virtuous, apolitical, and definitely not successful in his attempt to "paint out" the history of art with a field of black. Upon careful inspection, the all black paintings reveal themselves to be saturated with color. In each case, there is an undercoating of contrasting color —red, green, blue, and more. In each case as well, this undercoating is applied in forms—squares, triangles, even a cross. He explained these undercoats once as "evidence" he wished to erase with black. But the eye is irresistibly drawn to them when the paintings are on display. Often, in color photography, the undercoat registers and the black surface does not—to the consternation of Reinhardt's present dealers and doubtless the ghost of Reinhardt himself.

His career is therefore the triumph of schizophrenia, a merging of two completely different bodies of thought in one paradoxical work, the Utopias of activism and passivity. If I had the time or the inclination, I would go on a crusade to rescue Ad Reinhardt from the formalist interpretation, but as I cannot, perhaps one of you will. In the meantime, he seems to me a figure of immense esthetic and moral interest at once, one of the few Americans (Rauschenberg, for a while in the sixties, was another) to work in a three-dimensional context, uniting personal, political, and artistic concerns in one. I would like also to remind you of Reinhardt's opposite anchor, early in the century: Rodchenko's *Black on Black*, painted in 1918 to counter the spiritualist theories inherent in Malevich's *White on White*. It is an intriguing match. In Rod-

chenko the political impulse is explicit: he was also sure his paint-
ing meant the end of painting, in the service of an open revolution.
Reinhardt's revolution is implicit in politics, explicit in esthetics.
Rodchenko has also been called a Utopian, but I remind you that
he survived Stalinism.

Art permits the resolution and statement of extremes. In a talk
we had in 1966, Reinhardt took a very clear stand on this issue. "By
abstract," he said, "I mean fine and free." This is not the same as
license. Agnes Martin said the appeal of artwork is its exhaustion.
The making of art may begin in the mind—like literature—but it
never ends in easy abstraction, words typed on paper. It ends in
a physical act, and in an object, in the face of intense resistance
from the medium, or from the politics that surround the medium.
I had to travel three thousand miles (to Austria) to put my hands
on your television screen. But the work exists now, apart from me,
a presence in the world beyond the self where it began. It is a
Utopia in itself.

If I am right, art serves the psyche in a fundamental way, by
permitting the construction of extremes, often in irreconcilable
pairs. The act of construction separates it from language, for in art
the model is entirely existential, while in literature the model is
a received (if highly flexible) syntax and set of sounds. Vito Acconci
is a Utopian in spite of himself, though I do not mean "Utopian"
in the conventional sense. Which brings me to the very last line
I would like to draw between the art of the Russian Revolution and
the American non-formalists. It came upon me as I read two inter-
views: the first between Acconci and Liza Béar, in an old issue of
Avalanche magazine, and the second between an anonymous but
none too bright interviewer and Vladimir Tatlin, in Moscow in
1931, just a few years away from Stalin's petrifying decrees on art,
literature, and architecture. In the first, Acconci is at pains to
correct the interpretation of his art as basically elitist: he stresses
his love for the movies, for the Marx Brothers, for the poetry of
Pound, who combined "an ultra-intellectual structure . . . with

Vladimir Tatlin. *Flying Machine,* 1920.
Courtesy Moderne Museet, Stockholm.

uses of slang."[16] In the second, we hear Tatlin trying to do the reverse (how the political climate has changed!), as he answers questions about his last truly revolutionary work—*Letatlin,* a bird-like work of sculpture into which the viewer is meant to climb, and fly (in his mind).

—Tell me what this is: a work of art or a technological product?
—In what sense?
—I would very much like to know how I should understand your bird or air bicycle: as a demonstration of attractive forms or whether one can really fly with it, as with a glider. From a hill, for instance, or from a high tower, or up against the wind?
—I don't want people to take this thing purely as something utilitarian. I have made it as an artist. Look at the bent wings. We believe them to be aesthetically perfect. Or don't you think "Letatlin" gives an impression of aesthetic perfection? Like a hovering seagull? Don't you think? But the seagull can keep hovering behind a steamer for days, borne by the air currents. I count on my apparatus being able to keep a person in the air. I have taken into account the mathematical side, the resistance of the material, the surface of the wings. We have to learn to fly with it in the air, just as we learn to swim in the water, ride a bicycle, and so on.
—By what principle does the apparatus fly?
—Like a glider. But my wing can produce three sorts of movement, like a bird, apart from the tail. Also, the wings can produce small beats. You can "rock" yourself in the air. The man lies in the middle on his stomach, you put your hands and feet in the straps and go up against the wind. . . .
—How did you come up against this idea?
—It's a thousand years old, from the time of Icarus. I started from an organic form. I observed young cranes, how they learned to fly. I bought some cranes, and went to school with them. Young cranes are just as helpless against the wind as human beings. I want, also, to give back to man the feeling of flight. This we have been robbed of by the mechanical flight of the aeroplane. We cannot feel the movement of our body in the air.
—What practical importance does your apparatus have?
—The same as a glider. Has the proletariat no use for a glider? It is still too early to talk about future air bicycling, when the actual apparatus has

still not been tested. Now, in the spring, we are going out with tents and we're going to start trying it out on slopes. But, also, I really want to emphasize the aesthetic side of the thing. . . .[17]

Is Tatlin's bird a Utopian work of art? I leave that for you to answer. If you agree that it is, I hope you will also agree—now —that it is perfect only within itself, and that it touches no extreme other than its own. Beyond that, I am afraid, no work of art can go. As for life, it rarely tries even to begin such a journey.

NOTES

1. "Aligned with Nazca," *Artforum,* October 1975, pp. 29–36.
2. Ibid., p. 31.
3. "De Kooning: Painting Is a Way,' " *The Anxious Object* (New York, 1964), p. 111.
4. *Art-as-Art: The Selected Writings of Ad Reinhardt* (New York, 1975), p. xvii.
5. *"Trajectory, Will the Future Abolish Art?"* Critique lecture, delivered at and published by the Cooper Union School of Art and Architecture, 1971, p. 67.
6. Ibid.
7. "The New Analogy," Critique lecture delivered at and published by the Cooper Union School for Art and Architecture, 1971.
8. E. H. Gombrich, "The Ideas of Progress and Their Impact on Art," Biddle lecture delivered at and published by the Cooper Union School of Art and Architecture, 1971.
9. Ibid., p. 66.
10. Ibid., p. 14.
11. "The Arts and the Center of Power," Critique lecture delivered at and published by the Cooper Union School of Art and Architecture, 1971, pp. 19–20.
12. Cf. *Dada and Surrealist Art* (New York, 1968).
13. Exhibited at the John Gibson Gallery, New York, 1975.
14. Reprinted (New York, 1963), p. 117.

15. *Art as Art: Selected Writings of Ad Reinhardt,* ed. Barbara Rose (New York, 1975), pp. 63–64.
16. "Excerpts from Tapes with Liza Béar," *Avalanche,* Fall 1972, pp. 70–77.
17. Quoted in *Vladmir Tatlin,* catalogue published by The Moderna Museet, Stockholm, 1968, pp. 78–79.

Post-Modern Form: Stories Real and Imagined/Toward a Theory

A FRIEND TOLD ME over a dinner one night that the modern period had ended. I was glad to hear it, but surprised. I told her she was premature. "No," she said. "I heard William Rubin declare The End at the Museum of Modern Art last week." This made me quite curious. Some months later I finally had the opportunity to put the question to Rubin himself, who is a superior conversationalist. He can discourse on almost any subject or opinion for hours, when he has the time. But my question stopped him. He thought awhile, puffing on his pipe. "I didn't say that. I said that one characteristic of the modern period *seems* to be ending. That is the tradition of the private picture—private in its character and subject matter as well as in its destination—that is, for the small circle of collectors and friends of artists who sympathize with vanguard art. In France toward the 1860s, painters stopped making broad statements regarding matters of collective interest such as religion, the state, history, etc.—what might be called public statements (and which were usually intended for relatively public places: palaces, public buildings, churches, etc.). They began to make pictures that were smaller on the whole, intended to be hung in more intimate spaces, like that of an apartment, and were

more intimate in their address—that is, both their style and their content. Give or take a few exceptions, this held true for a long time, until very recently. Now you have artists working in all sorts of media that can't be confined to private spheres. Indeed, many of them are either too big (earthworks or giant minimal sculptures, for example) to fit even in museums or are of a character for which even the museum is not really necessary (I find most conceptual art more interesting in magazine format than on a museum wall). Even video, when the hardware will be sufficiently available—and that is just a question of time—will finally have no need for the museum, which is a stopgap aid to this young art. All this does not mean that the modern period—as characterized by the art of 1860–1960—has come to a definite end, but it does raise the question of whether we are not at the point of much more fundamental transitions than any which separated the various 'isms' that have followed one another in the history of modernism. Easel painting does not seem to be of interest to many of the most interesting young artists anymore. But this could change tomorrow. The situation is transitional and is very open. The appearance of a few geniuses who might renew easel painting would change one's thinking a lot. Until we have more perspective on this movement, we can only speak in terms of tendencies and directions."

That night I went home to Jane and told her I had something important to announce. "What?" she asked. "The modern period," I said, "has ended."

Newness, often in the form of technical innovation, is unquestionably a constant feature of modernist art (and one of the reasons why modernist art is a constant source of anxiety, not only to the bourgeois audience it frequently wishes to perplex, but to other artists as well) . . . it is a natural consequence of these researches and experiments that the artistic medium is brought increasingly to consciousness. Thus, in pursuing their desire for an exact representation of light, the Impressionists tended to upset the subtle balance between the illusion of depth and the design of the painting surface, thereby drawing attention to that surface. . . . The

insistence on the presence of the medium, whether it is an inadvertent consequence of technical experimentation, or the direct expression of an aesthetic ideal appropriate to a self-conscious and self-critical period, is, undoubtedly, one of the major characteristics of modernist art, and it does, of course, create new formal problems, some of them crucial. . . . A new problem of organization is posed. . . .

[Marshall Cohen, "Notes on Modernist Art," 1971]

Once upon a time, the king of Flat received a group of sailors who had journeyed around the world. He asked them what the world was like. "The world is curved, Your Highness." The king shook his head. What they said could not be so. "But it is," responded the sailors. "It is round as a woman's hip, as gently arched as her breast, as ripe as her ruby lips. It is a sphere, sir, hanging like a luscious apple in a forest filled with other spheres, each one as curvaceous, as round as—" But the king shrieked, making the sailors stop. The king insisted that the Flatness was a premise upon which all the laws, maps, and education in the kingdom were based. A great deal of money had been invested in Flat. Brave men had risked their lives in behalf of its doctrines. God himself was horizontal; each morning little boys and girls saluted the flag by stretching themselves flat out on the floor. One of the younger sailors objected. He was beginning to tell the king how light travels—a theory they had learned from a little Jewish gentleman on the other side of the world—when he was interrupted by the oldest sailor, who could see the fire burning in the king's eyes. "Perhaps Your Highness is correct," he said. "Perhaps what we saw and learned is simply an illusion." The king smiled and nodded. "That explains it," he said. "The world is curved."

Last summer I was in the desert with a sculptor. We passed through valleys that had not seen a human foot for thousands of years. We sat in the midst of stillness so complete that it was a presence. Occasionally an insect would fly past. After we had driven out to see his huge and lonely works, standing like isolated

pyramids in the sand, I asked him what he intended to build next. "The biggest CB antenna in the world," he said.

I forget who told me that art had nothing to do with politics. It seems a long time ago. Recently I met a man in a foreign country who spent ten years in jail because he had been seen reading the wrong art magazine. I asked him what was in the magazine, and he couldn't remember.

Finally the Minimal sculptor achieved what he had always hoped for but never—until now—achieved. He made nothing. His newest girlfriend—a luscious one—was with him when he did it. "At last," he said, "an object that is without meaning." "What is meaning?" she asked, innocently. The sculptor interpreted this as a hostile remark. "Everyone knows that meaning means something. You can speak about it. You can't put nothing into words." "You mean," she said, getting to know her new man, "if you can put it into words it is meaningless?" "Of course," he replied, as though to a child. "Nothing without meaning is nothing without words. Whereas a word without nothing can still mean what it means." There was a pause. "How big is this object you have made?" she asked. He held up his third finger, right hand. "Where is it?" she asked. He pointed to a spot on the floor. The girl immediately undressed, lay down on this spot, and spread her legs apart, with precise directional skill. The sculptor could not help himself. When he was finished, she asked him to describe what he had felt. The next day his work took a new direction.

A friend told me the following story. She saw the painter Peter Plagens hurrying down the hall and called out to him. She had heard that he was being offered a glamorous job to be art critic for a national magazine and wanted to know the answer. "I can't do it," he said brusquely. Was it the burden of painting and writing at once, she asked? "Yes," he said. Then, as he turned the corner, he shouted, *"They* won't let you do it."

Douglas Davis. *The Austrian Tapes,* 1974.
("Handing"), one of three five-minute segments. Produced by O.R.F. (The Austrian Television Network) in collaboration with Galerie P.O.O.L. (Graz).

When I was in Moscow, an intellectual there said the following. "The West is like a flowing river," he said, "the East is like a block of ice. You can swim anywhere in the river, and you won't change its shape at all. If you move an inch inside the ice, it cracks.

Form and Content approached each other on the infinite line, traveling fast. "Where are you going?" asked Content of Form. "To the end of the line," answered Form, "away from you." "So am I," said Content. Then they collided.

I think I was a teen-ager when I realized that television is high definition. I was very worked up about sex in those days. Every afternoon I would watch a talk show on the local Metromedia station because it featured a girl with a very large chest. I still remember her name, Aletha Agee. It got so bad—years later I can tell the truth—that I began to draw her name on the TV screen and even to sketch her breasts very quickly, when she sat for a while in profile, before the camera. This led me actually to touch her, and fantasize that the screen was flesh. Nothing is low definition where the imagination is involved.

It is always interesting to see what people say when they touch my hands on the TV screen in *The Austrian Tapes.* Here it is often understood as a good joke, or as an exploration of the box, or of the flat (gently rounded) screen. In Poland, a TV director looked at a photograph of the image and shook his head, refusing to speak. A lady from the Midwest wrote and said that it warmed her hands on a cold winter night and for that she was grateful. In Austria, there was a debate among European TV producers about it. Pierre Schaeffer, the director of experimental TV in France, was against it—we should be touching each other's hands, not the TV, he said —but thought it legitimate investigation. "We do this sort of thing all the time in Paris," he said, "but among ourselves. We would never broadcast it."

Noam Chomsky and I. L. Pavlov met in an all-white room to argue whether the mind is innately full or innately empty. "You're first," said Pavlov. "I have nothing more to say," replied Chomsky.

Not long ago I was dancing at a party with a story artist. I said, "Let me tell you a story." "But you can't tell a story," she said, "you can only *see* one." The band was loud and the devil was in me, so I replied. "I can't hear you," she yelled. I thought fast, for a change, and winked, quickly, back.

Harry Callahan says that human beings have no right to be happy. When people say that sort of thing they are usually playing their cards tightly, hoping for the pot as much as anyone else. It is like the painter who retreats from the world and by isolating himself whets the desire of the public to know him—Jasper Johns is just such an example. Nearly always we find contradictories existing side by side, needing each other. I never felt so hidden as when my name was appearing each week in a national periodical. The form in art struggles against meaning, the meaning against form. We think television is a mass medium, yet we perceive it as essentially private. The tape displayed in a gallery or museum context is inescapably public—the reverse of what is normally supposed. Is there a right and a left in the universe? If so, that implies a center, which we cannot find.

A little girl saw a famous artist walking down the street. "When do you make art?" she asked. "Tomorrow," he replied, still moving. "Why not now?" she continued. "I'm busy," he answered, passing her. "What are you doing?" "Thinking about what I made yesterday," he said, as he passed out of sight. When the artist came again the following day, the little girl started with the last question and worked backward.

Time decided one day to have done with Life. She was a harridan, much given to screech and bluster. "You have cheated me long enough," she said to Life, as he awoke one morning, rubbing

the sleep and—let us admit it—the revels from his eyes. "From now on," she announced, broom in hand, "I will do what I please. I'll clean when I please and eat what I please and play as I like. No more following after you. I'm keeping my own pace now." Life thought to answer, then decided it was no use, and turned over to sleep again. It was at this moment that Time, victorious, began.

Late one night in Boston we telecast *The Austrian Tapes* and *The Florence Tapes* on a commercial station. The viewers were invited to phone in their responses to the several acts involved—to touching the TV screen with their feet, their hands, their chests, their backs. Finally a man called in and said: "I've enjoyed this very much but now I'd like you to play a game with me, on my TV screen. Please get up and come over to the camera." I did what he asked, while the cameramen and producers held their heads in horror; I saw myself in the monitor with my hand right over the top of the screen. "No," said the viewer at home, "over to the right —further—further. Now down, lower, to the right-hand corner of the screen. Now press your thumb against it, hard." I did all these things. When I pressed hard, he let out a loud *"Ahhhhhhhhhhhhh.* Thank you very much." To this day, no one knows what he was doing there at home, in the privacy of his room.

George Steiner, author of *After Babel,* published in 1975, believes that there is an obduracy in language, a small preserve that every tongue, class, region, and person keeps to himself. This is the dimension of language that can never be translated. At the same time, he is fearful that this private preserve is being steadily reduced. "A diffuse rationalism, the levelling impress of the mass media, the increasing monochrome of the technological milieu, are crowding on the private components of speech. Under stress of radio and television, it may be that even our dreams will be standardized and made synchronic with those of our neighbors. . . . There can hardly be an awakened human being who has not,

at some moment, been exasperated by the 'publicity' of language, who has not experienced an almost bodily discomfort at the disparity between the uniqueness, the novelty of his own emotions and the worn coinage of words. . . . In some individuals the original outrage persists, the shock of finding that words are stale and promiscuous (they belong to everyone) yet wholly empowered to speak for us either in the inexpressible newness of love or in the privacies of terror." But this is the consequence of not thinking through the origin of radio and television as rigorously as we have thought through the origin of language. The origin is the same: the mind. Thus television carries with its power to disseminate and publicize the antipathetic power to derationalize everything it says and does. What language clarifies it can also mystify; yes, this is true. What TV clarifies it, too, mystifies more and more. Falsely defined as the bland art of the masses, TV hungers for terror, magic, voodoo.

"Where the subject matter has explicit race, sex, or class content, this content must be understood and experienced to the full extent that it participates in meaning." So wrote Lillian Robinson and Lise Vogel in "Modernism and History," in 1971, and I agree. But what is meaning? This is precisely the sort of question that cannot and should not ever be answered. For the answer, as Steiner warns us, can come only through the medium of the vulgate. It is as elusive and as central to our present concerns in art as the term "form" was to the painters of the fifties and early sixties, or as the term "quality" remains today, for certain critics. When we look back in time upon this period, we will think of acts of meaning—Beuys, his face painted gold, talking to a dead hare; Burden firing his rifle at an airplane, far beyond the reach of his bullet; Acconci masturbating under a platform in a gallery. One must know that these are acts shaped and formed by meaning— that everything in them responds to that need—or one knows nothing. The least that can be said about them (in the vulgate) is

that they do not call attention to themselves as mediums. It is almost impossible to discuss them in terms of materials, shape, time, image. The work of art must have a meaning beyond itself —this is an old thought, but when I use a term like "post-modern" I mean leaving the tradition of the new behind. Old things become new, now, and the new becomes old. I think sometimes of the terrible irony in a term like *"mean*ing," since its very appearance in art means the end of an obsession with *means.* We are not attracted to surfaces and interruptions in form anymore: they are the commonplace of the new. I am trying to return the mind to what it already knows, and has forgotten. When I went to speak to the president of the Astrodome in Texas about sending a voice signal to the global satellite from the floor of the stadium (a work, entitled *Seven Thoughts,* performed on December 29, 1976), he wanted to know what I would say. "I can't tell you that," I said, worried that he would not understand. "I want to know what it means," he insisted. "If I told you," I replied, nervous about saying too much, "you wouldn't know. If I don't tell you . . ." I hesitated, but went on. " . . . you will." He never replied to this point, but he let me use his stadium, which means that he agreed.

Time found man counting in the countryside. "What are you doing?" he asked. "I am giving a number to every second, minute, hour, day, week, month, year, and season. It's exhausting." "I have a better idea," said Time. "Count like this: *one . . . one . . . one . . . one . . . one . . . one . . .*" After he had listened awhile, man nodded his head. "I understand," he said, "but I can't make each *one* sound like the last, or the next." "Neither can I," said Time, and left.

Form is incidental to the quality of the message. Which is to say that it serves content, not that it dictates form. Form distinguishes between levels of excellence—in this I thoroughly agree with the Greenbergians. But the distinctions operate on ascending levels of subject matter, levels that are indeed structured by content. The

organization of a work in which both content and form are equal partners is thus always a mystery: we cannot separate one from the other. Nor is "style" the proper answer. A post-modern art must rid itself of the very notion of style, or trademark, because it implies that the organization (which defines the form) can be controlled by issues beyond content. Style is furthermore a betrayal of the meaning in a work of art, and the meaning inside us. It also rules out the use of old, remembered motifs, methods, and values, which are as desirable in the post-modern period as modern itself. Finally, style makes no allowance for time—the recognition of the fluidity and instaneity of our perceptions, thoughts, and feelings. What we perceive in one moment is of necessity different from that in another, though of course there is a connection. I know that what I am saying implies a hierarchy of content—that some subjects are inherently more important and demanding (and therefore deserve larger, less self-contained forms) than others. I could list the hierarchy right now, but I would simply duplicate what you already know.

Epilogue

Statement by Mr. Douglas Davis on H.R. 7216, the Arts, Humanities and Cultural Affairs Act of 1975. Given to the Joint House Subcommittee on Select Education and Senate Special Subcommittee on Arts and Humanities. November 29, 1975.

I CONFESS right away to you that I am no detached observer or critic of the matters before you. I am actively involved on three levels: as an artist (I received a National Endowment Artist's Fellowship to continue my work primarily in videotape and experimental television this past year); as an art critic for *Newsweek* and several art magazines; and as a member —some years ago—of a panel dispensing grants for the New York State Council on the Arts. But I am not going to plead any special cause—only a general one. I am going to try to separate myself and you for just a minute from the heated exchange of specific claims, to ask a radical question: Why encourage, support, and fund the arts at all? By "radical" I don't mean anything political, for the moment. The dictionary tells us that it means whatever is at the "root" of a word, or an issue. That is precisely what we need to do now, ten years after the first lonely struggles began in the Congress to support the arts, under the leadership of Senator Pell and Representative Brademas, and one session before we extend that commitment again.

It is a commitment that took slowly but came on fast. Certainly I am right to say that in 1975 the use of tax dollars to seed the culture is

politically acceptable, if not popular. Why? Some pessimists—including several of my fellow artists and critics—put it down to vested interest: now there is an arts bureaucracy (both federal and state) and an organized arts constituency, which any Congress ignores at its peril. But this answer also begs a question: Why was legislation in behalf of the arts popular in the first place, before the vested interest or the bureaucracy existed? Why is it popular now—according to recent Harris polls—even among people who are far from its immediate benefits? So I do not entirely agree with the pessimists. Nor am I so optimistic as to believe that we are all engaged in supporting bills like this one for noble reasons, divorced from self-interest. The National Endowments for the Arts and Humanities exist because we want them to exist—for mixed motives—and they are here to stay.

This is a major change in our cultural life, and therefore in the life of the nation. Never mind the comparatively small size of the sums involved: you don't need millions to build a great painting, as you do to build an airplane. Laying the National Endowment onto my field is like laying a multibillion dollar, federally sponsored airline onto the transportation industry. To judge from the testimony given here that I have read, you are being told time and again that there is only one problem before you, only one flaw in our record: the government isn't putting enough into the arts. Let me immediately say that the total appropriation is far less important than how it is spent.

More attention must be paid to the long-range implications—yes, the philosophical and esthetic implications—of governments getting into the arts, even a government as open to criticism and as afraid of itself as this one. Instead we are constantly being compared on a dollar-per-head basis to Denmark, or Luxembourg, as though foreign patterns of public patronage, heavy with bureaucratic implications, are what we need. I say the contrary, in agreement with choreographer Alwin Nikolais, who told the Associated (state) Councils of the Arts this summer: "I hope you, as champions of the arts and artists, never feel obliged to pattern our patronage after that of the foreign countries. By comparison even in our infant aid . . . we have far exceeded in accomplishment . . . anything done by a foreign country despite its tradition."

I would add only that we have accomplished great deeds in the arts

precisely because we are freed from tradition. The infant aid touches sparks because the friction is already there. The cultural vitality in the United States has been and still is present-tense-oriented, concerned with making and doing now, and if possible new, and therefore needs help, not direction or promotion, and certainly not a ministry of culture. The function of such ministers—with rare exceptions, like Michel Guy in France now—is normally to preserve what has been: huge sums for the Old Vic, for example, far less for living theater. The Triumph of American Painting —to borrow a title from Irving Sandler's book—occurred immediately after the war, with no funding from above.

The visual arts continued to explode, innovate, and to develop a public (as well as an international market) during the same period, not only without government help, but often against the grain of conventional taste. In fact, it is obviously difficult—if not impossible—for any ministry of culture to support an art that opposes the status quo. Yet it is often precisely the negative voice that renews the culture, as Artaud did in the theater and Duchamp and Pollock in painting.

Why fund the arts? I ask the question again. In a context of cultural vitality, the answer must of necessity be different than it is in other contexts. So must the method of funding differ. Often you are told that the cost of creation is going up (particularly in theater, music, and dance), and that is certainly true. But it is not only a matter of need on the part of the creators. The public needs, too. It clearly wants more art (to look at, think about, and even to buy), more services from its museums and theaters, more from the universities and art colleges: the number of students enrolled in the arts, (both studio and academic) are on a dramatic upswing, while other areas—some of them bread-and-butter areas—decline.[1]

I often read in the *New York Times* and elsewhere that the New York neighborhood in which I live—SoHo—is filled with rich, chic artists and radical-chic collectors, but the merest glance at the crowd sweeping up and down our streets on a Saturday reveals anything but that: they number every age, every section of the country (and the world), every status and occupation, every color—and needless to say, every opinion. Often we are told by a variety of self-styled populists (including, lately, Tom Wolfe, a man of the people if I ever saw one) that "high" or "vanguard"

about our culture abroad is precisely the reverse: its energy, ingenuity, and diversity. The same is true of American science, of course.

How can we preserve that quality? Here are some recommendations. Though they are couched in general terms, I assure you that they can be specified and organized as realistically as their alternatives. Furthermore, they are far from unique ideas: they make up an amalgam of complaints and suggestions that have been poured in my ear by countless colleagues and friends, most of them artists, but also middlemen (critics, curators, dealers, and funders) unable as yet to get your ear, or anyone's ear.

First: there must be a huge increase in grants made directly to artists. It is a continuing wonder and scandal to me that both the National Endowment and the New York State Council on the Arts put so little money straight into the hands of the men and women who in fact create the culture. I believe the figure in 1974 was $3.62 million from a total NEA budget of $72 million; the percentages in New York State are not even that good. Instead our art bureaucracies prefer granting "project money," tied to specific programs, or to cultural institutions. In New York State, the woods are filled with nonprofit arts organizations that never existed before the legislation creating the Council appeared. This is simply indefensible. "The artist has been forgotten," a friend recently wrote to me, though often the legislation is supported and passed in his name. If my first recommendation is not adopted, I predict we will see by the year 2000 a comic paradox in this country: a huge bureaucracy of funders feeding on itself. Surely there should be more equity in the figures I just quoted.

Second: instead of creating new arts organizations and bureaucracies to administer projects for artists, use already existing structures. In my own field, there are two main areas of professional competence already in existence, already serving organic functions. First and most important, there are hundreds of excellent university art departments and professional art colleges in the United States. It is they who should be receiving and administering the bulk of the project money in the visual arts—to commission new works, buy previous works, and appoint visiting artists. In addition, the professional contemporary art galleries—most of whom operate, media to the contrary, at a loss—ought to be eligible to receive federal help, just as Lockheed or Boeing is eligible. Most important of all,

they represent along with the nonprofit cooperative galleries (already eligible for aid) a countervailing source of power and decision-making. Their health guarantees a highly desirable decentralization, at the lowest possible cost to the taxpayer.

Third: a proposal related to the last. The easiest, cleanest way to aid visual artists—and cede them at the same time encouragement to follow their own inclinations, rather than a bureaucrat's or curator's—is to buy their work. Again, I say that college art departments and professional arts colleges, as well as contemporary art museums, offer a ready-made body of organized expertise and opinion through which such purchase funds could be channeled.

Fourth: the concept of "experimentation" in the arts ought to be formally recognized in this or any other legislation related to funding the culture. It is as necessary to the arts as it is to science or to business. I might add that our use of new media and concepts in the visual arts is a continuing source of interest abroad—one of our great strengths. Last spring I participated in the first large exhibition of video art (most of it American) in Latin America, at the Museo de Arte Contemporáneo in Caracas, Venezuela. More than 16,000 people jammed into the museum on the first day; the total attendance for the entire two-week exhibition was more than 65,000, imposing totals in a city where the work was largely unknown. But the pace of experimentation is steadily slowing down here now, in response to an increasingly conservative political, economic and social climate as well as a decline in sympathetic support from American critics, museums, and collectors, who are rapidly being outpaced by their European counterparts. A vital arts-funding agency would act against such a trend, if properly encouraged by you.

Last: there should be a consumer's agency—an ombudsman—in the arts. Jack Kroll (theater critic of *Newsweek*) has recently and rightly called for more confrontation—via the Endowments—between art and government. But unless there is a formal court of appeal, built into the structure of both Endowments, artists, dancers, composers, and choreographers will be afraid to appeal decisions or to protest policy. Thus the bureaucracy will not be able to correct and modify itself. I must credit this thought to Newton Harrison, one of the leading artists dealing in systems sculpture and also chairman of the Department of Visual Art at the University

of California at San Diego. It is his contention that no institution—whether it is the NEA or the U.S. government—can prosper without a built-in, established critical function. At the National Endowment, the ombudsman panel should be broadly based, including artists and critics from several fields, who are specifically authorized both to criticize and to process criticism from outside.

I doubt that much of what I am saying will make you happy. It will certainly not please the National Endowment for the Arts—which is as fair, intelligent, and admirable a cultural bureaucracy as any I have yet seen. But it is only a bureaucracy, and it must be criticized more openly and frankly than it has been to date. Furthermore, it is people like myself —who need and use the NEA as well as create the culture—who must do the criticizing. Rather than listen to me, the Congress would doubtless prefer simply to appropriate the funds to a ministry of culture and forget it, as often happens abroad. But that would be a disastrous policy. I go back to the question: Why fund the arts at all? Because the health of the entire culture and society depends upon it. Our decisions in this area have consequences far beyond our dreams. The culture is the result of the work of individuals, not of bureaucracies or of organization. That is why I have insisted on the prime importance of method, rather than money. Your end—your most important end—must be to free the creativity of the individual person, not to perpetuate an organization.

NOTES

1. Recent HEW statistics tell us that the ten-year trend in 1963–73 undergraduate degrees shows an increase in fine and applied arts that doubles the increase in engineering degrees. The Department of Labor Occupations Handbook based on the 1970 census forecasts that there will be four times as many men and women professionally involved in the arts in 1985 as there will be lawyers and doctors!

INDEX

Page numbers in italic refer to illustrations.

lakeway exit
off freeway r - on lakeway
straight to intersection. Thru
1 blank way, keep l
l on Indian ✗.
straight thru 2 intersection
until -